THE AUSTRALIAN SCAPEGOAT

Towards an antipodean aesthetic

Other Works by Peter Fuller

The Champions
Art and Psychoanalysis
Beyond the Crisis in Art
Seeing Berger
Robert Natkin
The Naked Artist
Aesthetics after Modernism
Images of God
Marches Past

Books edited by Peter Fuller

The Psychology of Gambling
Charles Rycroft's, *Psychoanalysis and Beyond*

For Stephanie
With love and thanks for turning my world upside down.

Acknowledgements

I would like to thank Professor Don Bradshaw of the University of Western Australia Press for his enthusiastic support for this book ever since we first discussed it in March 1985. I would also like to thank Alan Burns for his generosity without which this book would not have seen the light of day.

'Aesthetics after Modernism' was first delivered as the John Power Lecture in Contemporary Art, in Sydney, on 5 April 1982. The lecture was subsequently broadcast by ABC Radio, and issued as an audio-cassette. An abridged version of it appeared in the *Monthly Review of the Melbourne Age* and it was published as a pamphlet by Writers & Readers, in London, in 1983. 'Art in 1984' was first delivered as the Jill Bradshaw Memorial Lecture at the Western Australian Institute of Technology in Perth on 7 March 1984. The text subsequently appeared in an abridged form in the *Monthly Review of the Melbourne Age*, and in *Aspects*, a British art magazaine. It was also issued as a small pamphlet by W.A.I.T. 'Art and Post-Industrialism' was first delivered on 24 February 1985 as a contribution to the conference on the visual arts organised to co-incide with the 1985 Festival of Perth; it subsequently appeared in the magazine, *Praxis M*. The interview, 'Towards a Fuller Meaning of Art' was conducted by Colin Symes of the Brisbane-based magazine, *Social Alternatives*, in which the text first appeared. A version of it was also published by *Art Monthly* in London. Jill Bradshaw's paper, 'Australia—the French Discovery of 1983', first appeared in the Australian art journal, *Art and Text* under the bye-line of Jill Montgomery and I would like to thank Paul Taylor for permission to reproduce the article. I would like to thank all those involved in the original publications of these contributions, both for helping them to see the light of day in the first place, and for allowing me to collect them here.

I would also like to acknowledge here my debt to my friend, Fraser Harrison, in whose company I learned so much about the landscape of Suffolk; and with whom I share so many ideas about the necessity of developing a new 'natural' aesthetic. His book, *The Living Landscape*, is in some ways an 'English' counterpart to this text.

<div align="right">PETER FULLER, December 1985</div>

Contents

Foreword

During the past forty years some highly-distinguished writers on the theory and practice of art have visited Australia. Among the most notable who might be mentioned are Lord (then Sir Kenneth) Clark in 1947; Sir Herbert Read in 1963; Clement Greenberg in 1968 and Peter Fuller in 1982. Of these only Clark and Fuller have paid anything more than perfunctory attention to the nature of Australian art. Indeed for Read and Greenberg, then both facing the years of their declining influence it must have seemed as if they had been invited, like ageing divas, to visit the end of the world.

Nor can it be said that Clark was much interested in Australian art as a cultural development with its own history. He viewed it essentially in environmental terms. It was the reaction of one or two talented individuals to 'the strange continent' that held his interest—that is to say, Nolan and Drysdale. His interest in Drysdale (who apparently wanted to live his life out in the place) soon waned, but to Nolan, who for Clark was a genius after the manner of Benjamin Britten, he continued to give warm support. That was Clark's way. He was, you might say, so far as living artists were concerned, a genius spotter. Civilisation was the gift to humanity of the successive talents of the great. His most agreeable works are those that are concerned with genius, the work of such as Leonardo and Seurat. And so he kept a sharp lookout. There is much to be said for this patricianly, conservative view but for Clark, as for many of his countrymen, it was usually attended by an excessively Eurocentric vision. It was a vision in which he saw his culture threatened and tottering in his own lifetime. But he could not bring himself to believe that it was in any real danger. In any case his duty was, like Giotto's St Francis, to do what he could to prop it up. So that his support for Nolan, for all its unquestioned clarity of perception, may also be seen as an appropriation. Was there not in this quirky vitality, this naive genius à la Rousseau, a crude energy that might shore up the waning vitality of British art? For it was, we might recall, in 1947, the year that Clark began to champion Nolan seriously, that his former protegé Victor Pasmore experienced that dramatic and much publicised conversion to abstraction that came to so affect the teaching and reception of art in Britain. And the whole move to abstract art rested uneasily with the classical values of Kenneth Clark.

So Nolan became the first of those creative ones of that 1940's generation which revitalised Australian art whose task it was, at least in Clark's eyes, to assist in strengthening the waning vigour of British art. This is not the view of an uninvolved spectator. I knew them all. I lived through it. I saw it happening. It is also the way of the relationship between metropolis and province.

Herbert Read never revealed any deep interest in Australian art. This is to be regretted for he was a more sensitive man than Clark and his feelings were more finely attuned to the strengths and weaknesses of the modern movement. But by 1963 he was a tired and ageing man. The early modernism that he had championed in the 1930s in the masterly work of Henry Moore, Barbara Hepworth and Ben Nicholson had suffered a strange transformation and he knew that it was no longer liberating. It was now the art of a philistine establishment, it had also turned in upon itself to cultivate nihilism and despair. It had begun to deny the meaningfulness of life. Yet his vision was far too Eurocentric to allow him to imagine that anything in Australia might develop according to a different trajectory of values. That is to be regretted because it was to Read more than to any other writer that the young Australian artists of the early 1940s looked for intellectual and aesthetic support as they triumphantly broke from the local conventions that held them. His books provided them with a programme and a new sense of freedom. But by 1963 his central interests had turned away from adult art towards a psychological primitivism. His last hope for western society was that it might be saved from the tyranny of technocratic 'reason' by his programme for *Education through Art* in the schools of all the world. There was an enormous amount in favour of Read's advocacy of the importance of the creative imagination in the educational process, but there was also a deep anti-intellectualism at the heart of his Jungian dream and it has, in the event, led to an estrangement from the traditional skills upon which drawing, painting and sculpture (as in all other arts) depend. What looked like a programme for liberation only served to promote, because of its excesses, the denial of life that Read perceived in the forms that late modernism took during his last years. Institutions, for all their imperfections, are not so readily mocked.

When Clement Greenberg arrived in Australia in 1968 it quickly became clear that he possessed neither the saving sense of tradition nor the range of sensibility that is characteristic of Clark and Read in their best writings. But it was also clear that he did possess an enormous confidence in his own judgments that was both intimidating and, in a sense, engaging. One felt at times that art began for him with Edouard Manet, that is to the extent that it foreshadowed the ultimate triumph of American painting. He had become, by that time, armed as he was with a rigid post-Kantian belief in aesthetic judgment as at once personal and universal and the conviction that painting unfolded the logic of its own history, the leading prophet of late modernism in its condition of decline. He saw modernist painting, as he called it, as a kind of platonic billiard table that was levitating itself through History as it moved towards its final condition of ineffable flatness. But in the U.S.A. it had already reached that state in the mid-1950s in the black canvasses of Reinhardt; and

the death of painting was soon being announced upon all sides. But it was not so much the death of painting as the rejection of those spiritual values that had once inhabited it that was occurring. What Peter Fuller has described as a *kenosis*, the 'emptying out' of late modernism.

It is surprising that Greenberg allowed his theories to propel American painting towards such a dead end. For he possessed a good eye, but so far as American painting was concerned he was prepared to allow a determinist theory to rule his perceptions. He must have known that the paintings of Hopper are better than the paintings of Pollock. I was with him at that time when in visiting a commercial gallery in Sydney he pointed to a small Pro Hart and exclaimed 'now that's a fine passage of painting'. As indeed it was, though less could be said for the rest of the picture. But Greenberg was, I believe, also signalling that he preferred the figural expressionist painting of Australia (even in the late 1960s) to that of those unfortunate young Australian colour-field painters who had acquired their pictorial Americanisms at second hand in the London art schools. That was the pathos of it. To see them crowding about the Master waiting for his blessing. But he preferred what had come to be known as Antipodean painting. As I said he possessed a good eye.

Like Clark and Read however Greenberg took no interest in Australian art as a tradition. What could possibly come from this part of the world? 'You remind me', he told me not unkindly one memorable evening in New York in August 1968, 'you Australians, of the good people of Saskatchewan. You are all so honest, so naive.' I felt almost grateful to him for so revealing to me this blind spot at the heart of his perception. Because for Greenberg, as for Bryan Robertson, who curated the Whitechapel Exhibition of 1961 (the only exhibition of Australian painting abroad that has ever evoked anything more than a smothered yawn), we were redeemed by our innocence. But in this evil world innocence is usually in the eye of the beholder and distance can lend breadth to the view. At any rate I had already guessed in 1967 that Greenberg's commanding influence was almost finished. I doubt whether I would have invited him to give the first John Power Lecture in Contemporary Art had I thought otherwise.

Peter Fuller first visited Australia in 1982 to deliver, like Greenberg before him, the Power Lecture in Contemporary Art. Like Greenberg too he spoke with confidence but it was not the confidence of a critic speaking from the highly assured and heavily underwritten values of modernist formalism. Which is not surprising for by 1982 Greenberg's aesthetic position looked like the ruins of a burnt-out hotel on skid row. Fuller's confidence was expressed in a somewhat grumpy, embattled way that perhaps might have been expected from a comparatively young man who had just arrived from a society experiencing a prolonged state of crisis. Indeed his own critical position was a product of that crisis. His professional career had begun in 1968 the year that Greenberg gave the first Power Lecture. 'The tumultuous political events of that spring and the subsequent summer', Fuller informs us in *Beyond the Crisis in Art* (p. 11), 'were undoubtedly a formative influence on my emergent political and critical perspectives'. The political crisis of 1968 that is to say initiated

the process of thinking out for himself a radical critique of late modernism, a process that is obviously still incomplete. So that in 1982 we were confronted in Fuller by a different kind of critical mind, one that did not speak to us from a secure (and secured) aesthetic but one still in formation. It seemed that between 1968 and 1982 the distance between metropolis and province had diminished remarkably.

This closure, this diminution of psychical distance, made it possible for a distinguished critic from abroad to speak to us without patronage. For Fuller had his problems too. This is what I have found attractive about his writings. His determination to work out a fully-fledged aesthetic for himself, and one in which the concerns of society, of morality and of art all have their part to play. In explaining art he does not explain art away. So not surprisingly he has found himself embattled among those structuralists and Althusserian marxists who do. He respects intellect but is aware of the danger of allowing it to override perception. So that an engaging honesty often emerges in his writings as he seeks to revise earlier mistaken judgments and constantly define, and redefine his position. You may disagree with Fuller but you would have to be a nong not to know where he stood, whereas it would take more than the genius of Jean Francois Champollian to decipher the meanings of most of those who write, say, for *Art and Text*.

Perhaps it is because Fuller takes such pains to make his position clear that so many feel that it must be reactionary. For many years now artists have become uneasy in the presence of those who set out to make their position clear. For they have become accustomed to changing step to every new tune they hear. But Fuller, far from being a reactionary, is in the process of fashioning one of the most radical critiques of late modernism that we have witnessed in a generation. This is emerging from his experiences of 1968, his prolonged study of the work of Karl Barth, of Marx and Freud, of the object-relations school of British psychoanalysis as expressed in the writings of Charles Rycroft and D. W. Winnicott, of his deep respect for the work of Ruskin and Morris, the more recent writing of Marcuse on art, and the work of the Italian marxist, Sebastiano Timpanaro.

Despite the diverse, international character of such sources there is a strong regional character to Fuller's writings. This, I find to be one of the most attractive features of his work. He is aware that since the death of Turner a spiritual grandeur has been lost to English painting and that since the death of Ruskin and Morris no British critic of the arts has done much to recover it. With Fry and Bell and their minor disciples the British visual culture began to look increasingly to Europe and then, with lights dimmed with such as Bryan Robertson, to look increasingly to America. The tradition became provincial, giving increasingly less support to its own artists on the pretence of supporting 'universal' values.

It was a situation that I became acutely aware of during my first visit to England in 1948–50 and on later visits. That after Victor Pasmore's conversion to abstraction British art seemed to lose its sense of purpose or tradition, that people like Sir Kenneth Clark and Alan Bowness who were in a position to exercise an influence upon events felt helpless before the promotion of theories of art that were patently reduc-

tive and anti-human, products of what Fuller has since described as the 'mega-visual'; a failure of nerve that could only lead to the slow attrition if not the end of painting and sculpture as major areas of human achievement. Fuller's own writings are animated by the desire to reverse this trend and gain much of their energy from it.

It has led him to pay more attention to the nature of Australian art, in its most general aspects, than any of his predecessors. And I find it gratifying that he was the first person to grasp the trans-national implications of the Antipodean intervention of 1959 (that were its basic motivation) and led, despite the ideological manipulations to which it was subjected, to the Whitechapel Exhibition of 'Recent Australian Painting' of 1961. Again, presumably it was a case of distance lending breadth and clarity to the view.

As I read Fuller I gain the impression frequently that I am traversing my own past, the same involvement with the work of Marx, Ruskin and Morris, a similar attraction to theological parallels in the search for aesthetic solutions, the same delight that I found in reading Marcuse's book on art, and the same sense of moral repugnance before the solipsism of structural theory and Althusserian marxism. So that he either echoes my past or indicates position I might well have adopted, or come to adopt, had I thought the issues through as thoroughly as he has done. Need I say that I also frequently find myself in disagreement. But here I can only give the barest hints of such disagreements without attempting to develop oppositional positions in depth.

Fuller is impressed (as I am) by the fact that we are aware, simply by looking at the way his face and body are rendered by his Hellenistic sculptors, that the *Laocoon* is 'in pain'. But I cannot agree that this is caused by a biological response on our part. For as biological organisms we possess no access to art. Such access requires a state of consciousness and consciousness is not adequately described as biological though it can only occur within biological systems (and of course not all biological systems at all times). The admiration of a work of art, aesthetic valuing, requires the operation of memory, and though I do not doubt that neurophysical descriptions of the activities and modifications of certain sections of my brain can be provided by biologists when I remember they would not claim to provide me with any adequate account of what I remember or why I remember this rather than that.

Even if we should agree that the representation of a sensual experience is more appealing 'biologically' than say the representation of the conclusion of a battle, does that mean that the former is in consequence more aesthetically compelling? Is the *Surrender of Breda* no less a convincing work of art than Manet's Olympia? To argue that the biological realm must be involved in our aesthetic appreciation is only to reduce the diversity and variety of art.

Fuller rightly criticises Marx's somewhat hesitant and tentative suggestion that the enduring appeal of Greek art may be due to the fact that humankind perennially enjoys the freshness and spontaneity of childhood and that the Greeks were 'normal children'. But he does not seem to note that Marx is here describing childhood in a

biological sense as part of the ageing process. Here as in Fuller's case the argument from biology fails because it is reductive. Art is not a biological experience socially mediated; it is in itself a mode of social production. Baptism and Last Unction might be cited as socially-mediated rituals for birth and death but it is only in a very special sense that we might want to describe them as works of art rather than sacramental rituals.

We do not need biology to explain the enduring appeal of art. In one sense what we are confronted with here is little more than a tautology. The appeal of a work of art (or at least its potential to appeal) endures so long as the work, or its replications, endures. The Song the Sirens sang may still be a puzzling question to some, as it was to Sir Thomas Browne, but it can no longer exercise its appeal. In this regard it is important to note (though it seldom is noted) that aesthetic valuing by implication initiates a conservational programme. To say 'that's (aesthetically) good' is to suggest 'that's worth keeping'. Aesthetic valuing has worked to (among other things) preserve admired works of the past for our present valuing. Such works now inhabit our aesthetic environment and become available for contemporary judgment. So that we may admire the *Laocoon* expressing physical pain as we might admire Munch's *Scream* as an expression of psychological disturbance. In this regard it is insufficiently realised that not only works of art but all human productions, though emerging into history within a particular historic mode of production, continue to be 'consumed' until they pass physically out of existence. The enduring appeal of art is due primarily to the fact that art is conserved as an important aspect of the human heritage.

I found Peter Fuller's appraisal of the desert landscapes of Nolan and other contemporary Australian artists such as Williams most illuminating. He views their interpretation of the desert as an important original contribution to landscape as a universal pictorial genre, and as such of trans-national significance. That is an important insight. It may be that Nolan's generation experienced the image of the desert powerfully both as myth and as a recurrent and intimidating, contingent reality. At any rate during the worst years of World War II the imagery of Eliot's *Waste Land* was constantly present in many Australian minds.

> What are the roots that clutch, what branches grow
> Out of this stony rubbish? Son of man,
> You cannot say, or guess, for you know only
> A heap of broken images, where the sun beats,
> And the dead tree gives no shelter, the cricket no relief.
> And the dry stone no sound of water. Only
> There is shadow under this red rock
> (Come in under the shadow of this red rock),
> And I will show you something different from either
> Your shadow at morning striding behind you
> Or your shadow at evening rising to meet you
> I will show you fear in a handful of dust.

Yet I also find myself in agreement with Jill Bradshaw when she writes that the great emphasis upon landscape painting in Australia 'represents a refusal to come to terms with the environment that European society has constructed'. For there is undoubtedly a negative as well as a positive aspect to the long dominance of landscape in the Australian tradition. At its most sinister it might be seen as an appropriation at a spiritual level of a process that began with the physical acquisition of the land from its first inhabitants. Australian artists might do well to pay more attention to the nature of their own, in most cases, predominantly urban existence.

Yet I cannot agree with either Bradshaw or Fuller in the belief 'that the preoccupation with ancient aboriginal art and sites may yet again prove to be another escapist tendency'. Though there are dangers and difficulties in Australian artists of European descent attempting to use the motifs and designs of aboriginal art without any deep understanding or experience of aboriginal society that danger will be constantly taken. For this is one way in which the visual arts have always operated. The artists of one culture appropriate the motifs of another to widen and deepen their own aesthetic understanding. Consider how orientalising motifs enriched Greek art in the 7th century BC, how Irish celtic art enriched Carolingian motifs or how, nearer our own day, Paul Gauguin drew upon Indonesian motifs and his experiences of Polynesian life and art to develop the first and some of the finest expressions of a self-conscious modernism. While such forms of culture-contact invariably reveal processes of appropriation they also reveal *emphatic* processes by which of which one culture begins to understand, and sometimes to respect, another. Moreover there is a basic reason why such processes of contact and convergence are likely to develop increasingly in Australia. It will come primarily from those aboriginal artists of mixed descent who owe a deep allegiance, Peter Fuller might describe it as a biological allegiance, to both the European and the aboriginal traditions. It is already happening.

But these are but small points on large questions that demand further discussion. Peter Fuller's critical writings are both challenging and exciting in the way they stimulate us all to rethink the basic issues of visual aesthetics. In this regard his admirable essay 'In Defence of Art' published in *Beyond the Crisis in Art* should be highly recommended reading in all our art schools. Both for Australians who are Fuller enthusiasts and those who have not previously savoured his work this present book, which also contains the important essay by the late Jill Bradshaw to which I have already referred, will be found to be challenging reading.

BERNARD SMITH

Introduction: the Antipodes and I

In 1947—as it happens, the year in which I was born—Kenneth Clark made a trip to Australia. On the boat to Sydney, he put the finishing touches to what was, perhaps, his finest book, *Landscape into Art*. This had started as a series of lectures and Clark spent much of his time on board, 'painfully turning the spoken word into the printed text'.

In *The Other Half*, a volume of autobiography, Clark recalled how he had to fight off the attentions of young women who wanted to interfere with this creative process. 'I am fond of young ladies,' he wrote, 'but I am even fonder of work and independence.' A recent biography reveals that his priorities were not necessarily always the same, and I have sometimes wondered whether *Landscape into Art* might not have been an even better book if Clark had allowed himself a little dalliance on his outward journey and left those final corrections until the return voyage. For we know that when he got home, Clark began to tell his incredulous friends 'that Australia was about to add something entirely fresh to contemporary painting'. And, as Clark well knew, what Australia was adding had everything to do with landscape into art.

I made my first trip to Australia in 1982, and I went again in 1984, and 1985. These journeys have had deep and still continuing effects on my attitudes to art, landscape, and indeed nature itself. They have also changed my life in more personal ways. In one sense, at least, these Australian lectures chronicle my antipodean transformations.

In 1981, Terry Smith, of Sydney University's Power Institute of Fine Arts, wrote and asked if I would be prepared to give the John Power Lecture in Contemporary Art, the following year. (The series had been inaugurated in 1968, as Bernard Smith has described, with a lecture by Clement Greenberg, a leading American critic; it was intended to bring to the people of Australia, 'the latest ideas and theories'.) I must confess that at this time I knew very little about Australia, and less still about Australian art. I had no particular desire to go there. Nonetheless, this interest in my work emanating from the other side of the globe was gratifying and irresistible: I accepted without hesitation.

The main thrust of my paper, 'Aesthetics after Modernism', was the critique of

the modernist tradition. I believed then—as I still do—that John Ruskin and William Morris, two of modernism's earliest and most trenchant critics, still have much to contribute to the emergence of a genuine post-modern aesthetic. These two Victorians spoke prophetically about the failure of modernism in art, architecture, and cultural life.

I have never advocated nostalgic revival. Rather, in my Power Lecture, I called for a new aesthetics: if these are to be rooted neither in God, nor in historical progress, they must spring, it seems to me, from some new, imaginative response to nature. I have long been sympathetic to what Gregory Bateson, the anthropologist, described as 'an ecology of mind'—or the recognition that, if nature is not the product of mind, then mind itself is in some sense the product of nature and is therefore immanent within the evolutionary structure, and objectively discernible outside of ourselves.

'Aesthetics after Modernism' contains passing references to things Australian: I mention the Sydney Opera House; William Butterfield, the English architect of the Anglican cathedrals in Melbourne and Adelaide; Aboriginal art; and Eureka—a pathetic exhibition of very recent Australian art which I had seen in London just before I left. But these were all used simply as pegs upon which to hang an aesthetic position which I had arrived at before ever I set foot on the Antipodes. My Power Lecture contains no suggestion that Australia might have anything to contribute to the emergence of this new and post-modern art.

I do not know what response I expected when I went to Australia to propagate these views. Bernard Smith may well be right when he implies that my grumpy and embattled manner was what might have been expected from 'a comparatively young man who had just arrived from a society experiencing a prolonged state of crisis'. I think I also probably suffered from some vague intuition that since there was no Gothic architecture in Australia, it would be even harder to point to alternatives to modernism than it was in Britain. Even so, I warmed to Australia immediately. I had never previously encountered such a passionate enthusiasm for ideas—even if, more often than not, this took the form of animated rejection. Australian hospitality, I had been warned, was unstinting: this proved to be the case; I could not remember having enjoyed myself so well for years. I went from Sydney, to Newcastle, Canberra, Adelaide, Melbourne, Hobart, Perth, Brisbane, and back to Sydney, within a month. Sometimes I delivered as many as three lectures or seminars in a single day. Certainly it felt as if, as far as intellectual experience was concerned, I was giving out rather more than I was taking in. The Power Lecture schedule just did not allow much time for receptive sight-seeing, or the exploration of Australian culture and traditions. I used to say that I would be well-equipped to write a fascinating paper on Australian lecterns or airport departure lounges. Nonetheless, I was also very much aware that Australia was beginning to affect me deeply, and to change the way I saw and thought.

At first, it was very hard to put my finger on how this was working. But there was no doubt that the 'youthfulness' of Australia had something to do with it. I am no

crude determinist. Nonetheless, the comparative openness of Australian academic, intellectual, and artistic life did seem to me to have something to do with the explosive expansionism, the evidence of which was to be seen in the fabric of the great and growing Australian cities. Australia had quite a different 'feel' from contemporary Britain where it is impossible to avoid a sense of being in a country where the old machineries of government and industry alike are creaking, shaking, and gradually running down.

But the distinction I found myself wanting to make was not primarily social or historical. I am sure that Australians must be bored beyond tears with descriptions of 'first time' responses to their continent by Europeans. Nonetheless, it is impossible for someone born and bred in Europe to enter Australia and not be overwhelmed by its geography: books and images cannot prepare one for its terrible vastness. I had become used to the cabined, cribbed, confined spaces of crumbling London, and the neatly manicured fields, and trim Gothic churches of rural Suffolk. As I write these words, straining to recapture my first impressions of Australia, I am sitting at the desk where I wrote most of the Power Lecture before ever I went there. From time to time, I glance out of the window across Kiln Lane. Every 'natural' and architectural detail, each hedgerow, field, patch of woodland, cottage, or church, has a known human history—often stretching back for century upon century. Once John Berger, the art critic, visited me here. 'I might have known you would end up here,' he said. 'It is like every English landscape painting rolled into one.' And so, indeed, it is. I remember how four years ago, with the opening phrases of my Power Lecture formulating in my mind, I walked down the lane towards Street Farm. That afternoon, I borrowed the key, as I often do, to inspect the village church dedicated to St George, which stands on a Roman double entrenchment. Inside, there are some of the most beautiful carved wood bench backs and ends dating back to the fourteenth century. This was the land I was living in as I prepared for my first trip to Australia, and even though I received no more than a succession of momentary glimpses of the terrain outside the great cities, I could not evade an intuition of the dreadful *otherness* of Australia. I formed a flickering image of a second creation of strange flowers, trees, birds, and marsupial beasts, clinging to a habitable, coastal ribbon which fringed vast, uncultivated expanses of desert dust, emptiness, and natural dereliction. I recognised that the symbol and image of nature which this intractable land presented would inevitably require a revision of preconceptions based on my so very different European experiences.

Despite what Bernard Smith says about Kenneth Clark, there are indications that he, too, grasped this about the time that I was literally in my cradle. For example, Clark wrote about a flight he made from Adelaide to Perth 'over the interminable red desert, which increases one's already enormous admiration for the pioneer explorers like Burke and Wills'. Clark commented that everywhere else in the world discoverers have penetrated to places where there have been people, or the remains of human habitation. 'In Australia,' he continued, 'there was nobody and nothing.'

As Clark had just described his discovery of aboriginal art, and remarked upon

the cruelty and injustice with which the aboriginals had been treated, he must have known that this statement was not strictly historically true. But Clark had glimpsed something of the stark natural symbolism which this alien land proposes. Indeed, elsewhere he was to comment that in Australian landscape painting, as in all great landscape painting, 'the scenery is not painted for its own sake, but as the background of a legend and a reflection of human values'.

> (Come in under the shadow of this red rock),
> And I will show you something different . . .

Clark never proved quite able to incorporate his Australian experiences into his understanding of art and landscape. He once reported that when asked to account for his belief that Australian painters were about to make a major contribution he could, 'only mumble something about the light, and the dead white trees and the feeling of an Australian myth'. Before I left Australia, I had already decided I wanted to get closer than that: I knew I would be returning.

Indeed, over the next two years, back in England, I found my thoughts kept tracking back to what I had begun to see there. In my Power Lecture, I had drawn heavily on imagery taken from Matthew Arnold's *Dover Beach*; I had tried to evoke the way in which the long withdrawing roar of the Sea of Faith reveals naked shingles and a darkling plain. As I dug deeper into the writings of John Ruskin, and the rise and fall of a 'Higher Landscape' painting in Britain in the 19th century, I found myself repeatedly returning to the imagery of the desert.

From the middle of the last century, even those born in England's green and pleasant land had to face up to what it meant to be blown about the desert dust, or sealed within the iron hills. The old imagery of a God-given garden became less and less appropriate. Perhaps this helps to account for the vogue for Middle Eastern desert painting which captured so many British and Parisian painters in the 19th century. But, in the absence of any new and compelling models of nature closer to home, 'Higher Landscape' was evacuated; depiction of the natural world became sentimental or topographic. The scenery, in other words, was either painted for its own sake, or as a reflection of trivial, inconsequential, or 'unearned' values. This, I came to feel, was the tragedy of British landscape until the wars of the 20th century, paradoxically, enthused it with new imagery, meanings, and life. Henry Moore, Paul and John Nash, John Piper and Graham Sutherland were able to bring about a 'redemption through form' upon a scarred and injured terrain, and thereby propose a vision of man, and his relationship to nature, of a terrible and awe-inspiring beauty.

This was the context within which I began to become fascinated by the recent history of Australian landscape painting—especially the works of Russell Drysdale, Sydney Nolan, and Arthur Boyd. But the circumstances of my second trip to Australia were tinged with a sense of deep personal sadness. On my 1982 visit to Perth, I had stayed with Jill Bradshaw, who taught art history at WAIT, the Western Australian Institute of Technology, and her husband, Don, who was Professor of

Zoology at the University of Western Australia. As I recount at the beginning of the second lecture collected here, the three of us quickly became friends. In 1983, I was shocked to learn of Jill's sudden death in a car accident in North Africa. Don rang me and asked me to return to Perth to deliver the first Jill Bradshaw Memorial Lecture. (I was also invited to spend some time as a Visiting Fellow at the Centre for Fine Arts at the University of Western Australia, and to take part in a conference on the visual arts organised in connection with the Perth Festival.) And so, with something of a heavy heart, I flew out to Australia again in February 1984.

'Art in 1984', the lecture I gave in memory of Jill, was probably the first text I had written which manifested the deep effects my previous Australian experience was having on my thinking. I contrasted George Orwell's negative vision of an anaesthetic future with William Morris's dream of a decorative utopia. I was also concerned to elaborate a theme I had hinted at in 1982 in my comments on the 'Eureka' exhibition of Australian art which I had seen in London that year. That kind of Late Modernism which dabbled with mass media techniques, and aped the new technologies, seemed to me to be profoundly regressive and potentially deeply destructive. This sort of anti-art, though favoured by the 'international' institutions and magazines of art, colluded, in my view, with the destruction of aesthetic potentialities, and the advent of a world such as that which Orwell had described in *1984*. But it seemed to me that Nolan, Boyd, and in a rather different and special way, Fred Williams, had all begun to propose a new aesthetic, involving a new vision of the natural world, and man's place within it, which could lead to a discovery of a way out of and beyond the modernist impasse.

It was not difficult for me to recognise what these artists had learned from European painting. And yet I had come to feel that they had used what they had learned to speak of an experience of nature which we Europeans could only glimpse occasionally through the savage ecological brutalities of war. They seemed to me to have done this with a freshness and originality of vision which sprang out of their perception of that nature which Australia proposed, a nature in which the great *memento mori*, the skull, or knob of bone, is never far beneath the soil skin. I came to the view that this vision was of far greater potency, and not only to Australians, in the 20th century, than a cottage garden decked with dog-roses. Tragically, however, it seemed to me that the development of this great vision had been stunted and occluded by the enthusiasm since the late 1960s in Australia for the latest fads and fancies of the late modernist 'international' art.

It was, I think, appropriate to make this intervention in Perth. Again, it was interesting for me subsequently to read Kenneth Clark's reminiscences about the visit he had made to the city in 1947. Clark pointed out that the sight of the 'terrible desert' had made it all the more of an 'enchantment' to arrive in Perth—a city which he declared to be 'arcadian' and 'completely Victorian'. To stay there, he says, was 'like a journey in time'. Perth seemed to him to be an earthly paradise, full of green sward, the most beautiful flower gardens he had ever seen, and blessed with an inexhaustible supply of fresh water and the best climate in the world. Perth, as he

pictured it, was a garden city, surrounded by 'huge fields of gladioli' and flourishing vineyards.

Of course, pockets of the old Perth still remain: but the city has long since lost any resemblance it once had to *News from Nowhere*. Most (but not quite all) of the beautiful Victorian decorative architecture has been demolished to make way for rows of the most tawdry and unimpressive 'international style' skyscrapers to be found anywhere in the world. Perth has not lost its fascination as an oasis of human habitation poised on the edge of a lonely ocean, and the almost limitless emptiness of the Great Western Desert. But what it offers the visitor now is less arcadian than Orwellian: for Perth is a great city which has been brought to the brink of architectural and environmental ruin by precisely those destructive and philistine modernist credos which so many of its artists still wish to defend. I am sure that if Kenneth Clark had stood in the middle of the odiously 'brutalist' 1960s campus buildings of WAIT, where I delivered my memorial lecture for Jill, he would not have written, as he does in his autobiography, 'I felt I could have stayed in Perth for a long time'.

Not long after I had delivered the lecture for Jill I went to the north west of Australia with Don Bradhsaw, who was leading a field trip one of the principal aims of which was to further his study of desert reptiles. This journey confirmed the sentiments which had been welling up within me concerning Australia and its landscape. I was later to set these down in an article about the Pilbara paintings of Fred Williams, which I was lucky enough to see in Sydney just a few days after my own visit to the region. (This piece was collected in my volume, *Images of God*.) I found the Pilbara a land of extraordinary beauty, and yet of terrifying inhospitality, a region where, after the worst cyclone for more than a decade, everything, it seemed, was leaping up and scrabbling for life. I found the deceit of the bush strange too: the dark red sand, glistening with 'desert varnish', looked moist and fertile. In fact, it could not have been more arid. The harsh, serrated spinifex grass, which tears the skin, could also appear almost lush. In his paintings of this gorgeous wilderness it seemed to me that Williams had brought about a 'redemption through form'.

The zoological work which Don was doing also affected my thinking at this time. Some of his energies were devoted to the study of two very closely related reptile species, and I sometimes went out in the bush with him when he trapped these lizards with a rod and line. Intriguingly, the work he was doing on the ecophysiology of these modest creatures was knocking another nail into what Richard Lewontin and Stephen Jay Gould, American biologists, have described as the 'adaptionist programme' and its 'panglossian' excesses. According to the vision of nature, which has dominated European biology this century, natural selection is *so* important that adaptation tends to be seen as the necessary outcome of its operation and the sole legitimate explanation of diversity in organic form and function.

But Don's lizards pointed towards rather different conclusions. For example, the two species were not only very closely related: they shared the same rocks and foods. And yet their breeding habits varied considerably. One bred like a tropical creature, after the summer rains; the cyclone that had swept through the region before our

visit had set these ring-tailed dragon lizards off. But the other breeds in October and November, the Australian spring. This is a completely inappropriate pattern for this region; but it is remarkably successful as a species—although this is as far north as it ever gets. In north western Australia, natural selection has not decided between these two species: both co-exist and prosper. As Don puts it, such evidence implies a need for a reappraisal of our ideas concerning the nature of adaptation in biology and the role of modalities other than simple natural selection in procuring evolutionary change. The more that one looks at these reptiles, the more one comes to realise that they have no very specific adaptedness to their desert *milieu*: or, put another way, reptiles which live in regions where water is never scarce are physiologically very similar to lizards which inhabit the arid world of the Australian outback. I found I was beginning to wonder whether reptiles, perhaps like flies and men, owed their evolutionary success not to any 'fine tuning' with the environment, but rather to the development of equipment which enabled them, as organisms, to cope with whatever environment arose.

Could the 'panglossian excesses' of the adaptionist programme have arisen from a desire to rehabilitate an old religious idea into the stark and alien soil of nineteenth century Darwinism? The classical Darwinian view had swept away the static grandeur of a divinely ordained 'Great Chain of Being', and replaced it with a fallen nature, governed by chance, incessant competition, and a struggle for survival. But the panglossian elaborations of adaptionist ideas re-affirmed a new sort of 'natural, harmony' between existing (successful) species and their environment. It seemed to me that there was an aesthetic equivalent to all this in the desire, despite all the insights of the 19th and 20th centuries, to conceive of nature still as a garden, divinely ordained for the enjoyment and nurture of man.

One certainly encounters panglossian fallacies in, say, thinking about traditional aboriginal societies. Among artists, in particular, I frequently come across the myth that traditional aboriginal societies existed in some sort of state of grace with nature, i.e. they enjoyed some sort of 'natural' harmony which we have lost through advanced technology. In fact, the hunter-gathering techniques of the aboriginals involved almost 'scorched earth' policies as a way of life: they would pillage a particular patch of land in search of food, and then move on. Whatever traditional aboriginal societies have to offer us, the way in which they related to nature constituted no kind of balanced, reciprocal 'ideal', or model, for the future. Indeed, their techniques differed in scale, rather than quality, from contemporary Australian agribusiness, which is currently mining the top-soil of the narrow, fertile, coastal fringe seemingly without a thought for future generations.

And so, when I flew back to Perth from Port Hedland, I was beginning to realise that the path beyond the modernist impasse would involve the elaboration of an aesthetic, imaginative, and ethical relationship to nature of a far more radical and disturbing kind than I had previously supposed. But these were not the only thoughts preoccupying me. Just before I set off to the north west with Don, I had met Stephanie Burns, an art student, from Claremont School of Art in Perth, who

attended most of the talks and lectures I gave at the University of Western Australia as part of my work as a visiting Fellow at the Centre for Fine Arts. Over the next few days, before I left for Sydney, Stephanie and I saw a good deal of each other. After I returned to England, she came out to join me there. We decided to get married, and returned to Australia in order to do so in February 1985.

Once again, I was invited to take part in a conference about the visual arts organised in connection with the Perth Festival. The talk I gave was called, 'Art and Post-Industrialism', and in it I pressed more strongly than ever my views about the failure of tacky 'internationalism' in the arts. I had been provoked by a mediocre exhibition, 'The British Show', which was on exhibition in Perth at that time. With the exception of paintings by Frank Auerbach, Lucien Freud, and Leon Kossoff, this consisted of the most banal and depressing *art officiel* preferred by the Arts Council of Great Britain and the British Council. I dismissed this stuff, and its Australian equivalents, as BICCA, or Biennale International Club Class Art—and I used the festival as an opportunity to celebrate the value of an informed provincial vision, and of conservationist aesthetics.

I argued more strongly than before that Australian artists were in a unique position to make a major contribution to the emergence of a genuine post-modern aesthetic, if only they attended to the 'natural symbols' with which the land presented them. I recalled how at one point, as we drove north in the Zoology Department's landrover, Don and I had glanced out of the window at the same time. A mangy sheep stood in a landscape of skulls and dry red sand. Don said exactly what I was thinking, 'The Scapegoat'; and the point was forcefully brought home to me that Australian painters were in a unique position to pick up the threads at exactly the point where British 'Higher Landscape' had become evacuated, and failed, in the mid-19th century. For the Australian landscape painter is compelled to begin with a conspicuously godless, intractable, terrain. This incident, and the insight that stemmed from it, have given this collection its title.

Nonetheless, I am convinced that despite its great achievements, the Australian aesthetic which began to emerge in the 1940s was only a beginning—but one which was tragically over-grown by the proliferation of the arid, anti-aesthetic, imported spinifex weeds of BICCA. Such pseudo-internationalism cannot be opposed by a blinkered nationalism. There were important continuities between the best Australian landscape paintings of Sydney Nolan, Arthur Boyd, and Fred Williams, and the highest achievements of European art: indeed, these great Australian painters could not have achieved what they did if they had not steeped themselves in the great traditions of Western art. That is as things should be: the cultural roots of white Australia are European, and will always remain so.

Even so, the informed provincialism, and aesthetic conservationism, which I am advocating no longer imply a subordinate status in relation to a strong, distant metropolitan culture. It is legitimate to question the degree to which Australian culture was ever simply a pale reflection. For example, on my own visit to Melbourne, I became convinced that William Wardell's St Patrick's Cathedral was one

of the finest buildings of the 19th century Gothic Revival to be found anywhere in the world. (Kenneth Clark and Nikolaus Pevsner held similar views about Wardell's masterpiece. Yet what Australian art historian has ever made a serious study of the building?)

Today, of course, there is no longer a strong aesthetic tradition in Europe, or come to that in America, within which Australian artists and architects can work to greater or lesser effect. Modernism is dying. In this situation, what is happening on the periphery becomes central: or rather, it may begin to create a new centre. In this book, I argue that the image and symbol of nature which Australia proposes has a significance which extends far beyond the shores of the antipodes. For the legend and human values proclaimed through the attempt by painters to come to terms with the Australian landscape may eventually be seen to have a universal relevance in the closing years of the 20th century. Afterall, it is not only Australians who are struggling to live at peace in an alien world of finite resources, which constantly threatens to disintegrate into a desert of sand and charred bones. Perhaps that is what Clark dimly intuited when he felt he could only 'mumble something about the light, and the dead white trees and the feeling of an Australian myth'. If this book does anything at all to stimulate contempt for BICCA, and enthusiasm for the revival and development of a true antipodean aesthetic, then it will have served its purpose. Europeans may yet feel compelled, quite literally, to *look to* Australia.

PETER FULLER
Stowlangtoft, Suffolk, December 1985

Aesthetics after Modernism

A spectre is haunting Europe, America, and no doubt the Antipodes as well: the spectre of Post-Modernism. Western culture is undergoing a transforming shift in its 'structure of feeling'. But perhaps the image of a revolution in taste is wrong, because what is occurring in aesthetic life today is recuperative, and, in many ways profoundly conservative. Of course, this aesthetic conservatism cannot be equated with the mood of political conservatism that is infecting Western societies; indeed it may have more in common with, say, the 'progressive' conservationism of the ecological lobby, or the anti-nuclear movements, than with anything that might comfort Reagan, Thatcher, or Malcolm Fraser.

Let me cite some specific examples. Take painting. When I set out as a professional critic in the late 1960s, the history of recent art was still presented as an ever-evolving continuum of mainstream fashions. Museums, magazines, and books encouraged the view that Abstract Expressionism gave way to Post-Painterly Abstraction and Pop, which are followed by Minimalism and Photo-Realism which, in turn, inevitably gave way to such non-painterly activities as Conceptualism, 'mixed media', photo-texts, Theoretical Art, and so on. Thus in the early 1970s, the assertion of 'The Death of Painting' had become a commonplace of 'progressive' taste. Art students, for example, seemed preoccupied with the arrow of the so-called 'avant-garde' as it sped on down an ever-narrowing tunnel in which more and more of the painter's traditional concerns were shed.

Last year, however, a massive exhibition at London's Royal Academy heralded, 'A New Spirit in Painting': a 'turning back to traditional concerns'. The 145 big paintings on show had all been made within the previous ten years by artists as various as Pablo Picasso, Balthus, Guston, and Hockney, and a younger generation of American, British, German and Italian painters. According to the organisers this demonstrated, 'Great painting is being produced today', and presented 'a position in art which conspicuously asserts traditional values, such as individual creativity, accountability and quality.' Thus we were told that for all its 'apparent conservatism' the work on show was 'in the true sense progressive.'

Or look at British sculpture. Back in the early sixties, when Labour leader Harold Wilson was talking about 'the white heat of the technological revolution', Anthony

1

Caro initiated a revolution in sculpture by going 'radically abstract'. He abandoned all reference to natural form, and jettisoned traditional sculptural materials and practices in favour of painted, prefabricated, industrial components joined together by welds. Sculpture, Caro said, could be anything: and his students at St Martin's School of Art proceeded to dissolve the art into the mere placement of unworked materials in heaps, piles, stacks, and bundles, or, worse still, such unsculptural activities as photography, events, and performance. But today, our best younger sculptors are simply refusing the history of the last twenty years; they are taking up the challenge of what had been done in sculpture before Caro's revolution and are returning to direct carving, modelling, and the making of sculptures rooted in the imagery of men, women and animals.

Inevitably, these shifts in painting and sculpture are affecting art education too. Twelve years ago, in Britain, it was officially stated in the second Coldstream report that the purpose of an education in Fine Art was not the study of painting or sculpture but the pursuit of an attitude which could manifest itself in almost any way. In the 1960s, art schools had been built without even the facilities for life drawing, but mixed media, photo-based techniques, and what-have-you proliferated. Today, it is the students themselves who are demanding the right to work from the model: some are even choosing to study anatomy from the cadaver again. Similarly, of their own volition, they are flocking out into the fields, hills, and mountains of Britain, once more armed with sketch pads and boxes of water-colours.

But this movement of taste extends beyond the Fine Arts: I well remember how, back in the late 1960s, 'mass production' was held up as the condition to which all art should aspire. Reproductions, multiples, and photographs were deemed somehow 'holier' than originals or unique objects. Today, that is changing too. John Ruskin once rejected 'the common notion of Liberalism that bad art, disseminated, is instructive and good art isolated, not so.' 'The question,' he explained, 'is first . . . whether what art you have got is good or bad. If essentially bad, the more you see of it, the worse for you.' We, too, are realising that Bauhaus notwithstanding, full aesthetic expression and mechanical production are incompatible. Suddenly, in Britain, the 'arts and crafts', hidden away in fustian obscurity since the 1930s, are re-emerging on the side of the angels. In a country ravaged by recession, the craft revival—symbolised by the establishment of an official Crafts Council, with palatial new galleries—has been among the most conspicuous cultural phenomena of the last decade.

But this shift in taste is nowhere more apparent than in architecture. Sir Nikolaus Pevsner, distinguished architectural historian and author of *The Pioneers of Modern Design*, once held the view that, in our time, 'form must follow function': he thought the International Style was the only possible path for architecture today. Back in 1961, Pevsner found himself puzzling over plans for Sydney Opera House. At that time, he was crusading against 'The Return to Historicism', by which he meant that a few renegades were deviating from today's style to create buildings which, as he put it, 'did not convey a sense of confidence in their well-functioning'.

So Sir Nikolaus raised his lance to tilt at imaginative, expressive, and decorative elements—which he regarded as anachronisms—in recent building.

But what could he say of Sydney Opera House? Pevsner had too astute an eye to reject it out of hand. And yet, of course, it could not be accommodated by any of the criteria functionalists held dear. So Pevsner was forced to suggest that maybe Utzon's sail or shell shapes were structurally necessary after all. Or, then again, perhaps opera houses were a 'special case'. 'It is at least arguable,' Pevsner wrote, 'whether for so festive a building as an opera house, in so spectacular a position as the Sydney Opera House occupies, strictly functional forms would not have been too severe.' Nonetheless, such 'funny turns' by famous architects were not to be encouraged. They tempted lesser men to stray. A dangerous revolt against rationalism was seeping into architectural practice. Pevsner re-affirmed high functionalism against all such deviations. 'The individual building,' he argued, 'must remain rational. If you keep your building square, you are not necessarily a square.'

Twenty years on, of course, heresy reigns supreme—and not only in spectacularly positioned opera houses. No one is keeping their buildings square. Irrationalism abounds and ornamentation is flooding back. Even Philip Johnson, erstwhile originator of the International Style, is opportunistically welding bits and pieces of classical decoration onto his new sky-scrapers, just like a younger generation of self-styled Post-Modern Classicists.

Inevitably, the art of the pre-Modernist past is being re-evaluated too. Have you ever heard any one say before that William Butterfield—Victorian master of 'constructional polychromy', and architect of Melbourne and Adelaide cathedrals—was a greater architect than Mies van der Rohe? Well, you have now. And you will be hearing a lot more such judgments in the near future. The great pariahs are coming in from the cold! As a young proto-Modernist, I was taught only to revile the memory of Edwin Landseer, painter of *The Monarch of the Glen*, and Victorian doggie pictures. Similarly, Edwin Lutyens, extravagantly expressive architect to an Edwardian imperial class, was always held up to me as what was wrong in architecture until Modernism cleaned it up. As for William Burges, High Victorian designer … well, in my youth, he was just *unspeakable*. But very recently in London you could have seen within just a few weeks national exhibitions of Landseer at the Tate, Lutyens at the Hayward, and Burges at the V & A. Indeed, when I left England, an exhibition of Butterfield's working drawings had just opened at a commercial gallery usually devoted to 'mainstream' twentieth century art. Such a line-up would have been inconceivable ten years ago.

I think it is obvious that there is much about what is going on today that I welcome. For example, the renewed interest in observation, natural form, imagination, drawing, and traditional 'painterly' and sculptural skills in the Fine Arts. I am delighted that, in British art colleges at least, pseudo-structuralist photo-texts are at last giving way to life drawing. I am also glad to see this interest in the crafts, rather than the mass-produced, and the waning of the mechanical dogmas of the International Style in architecture. All this indicates that an 'aesthetic dimension' of life

which had been squashed and marginalised by modern technology and economic structure may be seeking to be born again.

But, it seems that contemporary society has a pelvic aperture of steel: at least this 'aesthetic dimension' appears crushed and warped even before it has seen the light of day. Certainly, it is having difficulty in making itself manifest in a compelling or coherent way. Thus, though the rhetoric surrounding that exhibition, 'A New Spirit in Painting', struck the right notes, most of the works actually shown (especially those by the younger generation) were, quite simply, awful. Their inflation of over-weening subjectivity certainly did not prove to me, at least, that great painting was in fact being made today. Similarly, in the crafts, however skilled and conscientious individual makers may be, their work always falls far short of the great traditions of handicraftsmanship of the past. And, as for architecture . . . We have already seen and heard of enough follies (like buildings whose walls create the illusion they are crumbling), arbitrary ornament, and debased symbolic structure (e.g., houses in the shape of toy ducks, or restaurants built like hamburgers) to begin to feel a certain nostalgia for that 'rationalism' which one was once so glad to see go. So, what are we to make of the vicissitudes of the 'aesthetic dimension' in our time?

I am about to paint with a brush as broad as that of those new-spirited expression-istic painters whom I have just criticised. I need to demonstrate that this 'aesthetic dimension' was a significant potentiality of our species, but one which has been pro-gressively menaced and emasculated in recent times. I also want to show how Late Modernism, in particular, colluded with this betrayal of the 'aesthetic dimension'. Then I will be in a position to estimate the mutant protests of the last few years against incipient 'General Anaesthesia', and to present my prognosis for 'Aesthetics after Modernism'.

Of course, this phrase, 'the aesthetic dimension', is something I have plagiarised from Herbert Marcuse's last great essay where he argued that when art is faithful to its own aesthetic form, it 'breaks open a dimension inaccessible to other experience, a dimension in which human beings, nature, and things no longer stand under the law of the established reality principle.' Thus Marcuse set himself against all mani-festations of what he called 'Anti-Art'—ranging through collage, mixed media, and Dada-esque activities—which he perceived in recent Modernism. Such renunciation of aesthetic form was, he said, 'abdication of responsibility' because 'it deprives art of the very form in which it can create that other reality within the established one— the cosmos of hope.' For Marcuse, as for me, 'The encounter with the truth of art happens in the estranging language and images which make perceptible, visible and audible that which is no longer, or not yet, perceived, said, and heard in everyday life.' I want, now, to take up these themes where Marcuse left them off by asking whether we can, as it were, root this great, if threatened, human potentiality in the biology of our species.

This has been a preoccupation of my recent work. Evidently, I can't rehearse all my theories and findings here, but I want to reiterate certain points to make my argument clear. I think it probable that, in its narrowest sense, 'aesthetic experience'

is the pleasure accompanying congenitally given responses to certain auditory and visual stimuli. Such a rudimentary sense of beauty is observable among, say, birds and fishes in their responses to tunes, patterns and ornament given by nature. These proto-aesthetic phenomena always seem to be bound up with processes of identification with the species-group or material environment, and, simultaneously, with the way in which the organism differentiates itself from its environment: pattern serves the purpose of camouflage and display. In our species, however, the pleasurable response to such stimuli seems loosened from its original biological function: furthermore, sensuous impressions which give rise to aesthetic experience evoke a wide range of nuanced feelings, which merge with a labile world of symbolisation, imaginative metamorphosis, and representation. Thus, whatever pure formalist painters may tell us, we can no more *reduce* aesthetic experience to instinctive response than we could reduce love to what goes on in our erectile tissues or vaginal juices.

But the aesthetic life of man differs from that of the animals in another way too. Our aesthetic experience is not just a matter of subjective response: rather it is linked to certain manipulative skills. Man, born naked, is ornamented not by nature but through his own handiwork; and he has the power to extend that process of ornamentation from his own body into the world around him. Finally the ornamental impulse merges into the making of autonomous representations of what he has seen, dreamed, or imagined.

Now why in man, uniquely, should aesthetic life be enmeshed with symbolic transformation and expressive *work*? That is a long story I have tried to tell elsewhere. But, broadly, I believe that our capacity to make and enjoy art was a by-product of certain evolutionary changes in our species which reached a climax about 40,000 years ago. Certainly, historically, these changes were accompanied by the emergence of a higher culture: the most significant of them were the prolongation of the infant-mother relationship, and, secondarily, the rapid evolution of the human hand.

Why did this extension of the infant-mother relationship prove so important for the aesthetic and cultural life of man? Well, the young of other higher animals are compelled to relate immediately to reality if they are to survive. The piglet must fight against its siblings for its place on the line of teats within instants of birth. But the human infant has not even the wherewithal to seek out the mother's breast when it feels hungry: the mother must *present* the breast, and by extension the world, to the infant, if it is to go on being.

Donald Winnicott, a leading British psychoanalyst, once explained how *subjectively* this utter dependence of the human infant gave rise to a feeling of absolute independence, of God-like omnipotence. When the infant feels hungry and the breast is presented, he experiences a 'moment of illusion': the illusion that he can create a breast, and thereby an external world, which will nourish and succour. Thus the human infant *imaginatively creates* the world to which the young of other animals are constrained to relate functionally. Only slowly does the human infant come to accept the world as existing independently of himself or his creative powers.

Such acceptance, Winnicott called 'disillusion' and associated with the frustrations of weaning.

'The Reality Principle,' Winnicott once wrote, 'is the fact of the existence of the world whether the baby creates it or not. It is the arch enemy of spontaneity, creativity, and the sense of Real . . . The Reality Principle is an insult.' But, as Marcuse rightly saw, in art, 'human beings, nature, and things no longer stand under the law of the established reality principle.' Winnicott can help us to understand why this is so.

He points out how as the infant goes through disillusion, he begins to make use of 'transitional objects'—such things as rags, dolls, and teddy bears to which young children become attached—which belong to an intermediate area between the subjective and that which is objectively perceived. Almost as consolation for the lost capacity to create the world, the infant establishes an intermediate area of experience, or 'potential space', to which inner reality and external life both contribute. Thus the infant seeks to avoid separation by the filling in of the potential space with the use of symbols and all that eventually adds up to a cultural life. For, as Winnicott puts it, no human being is ever free from the strain of relating inner and outer reality: hence the continuing need for an intermediate area that is not challenged. The potential space, originally between baby and mother, is ideally reproduced between child and family, and between individual and society, or the world. Thus Winnicott described this intermediate area as *the location of cultural experience*, which, as it were, provides redemption from the insult of the Reality Principle.

One way it does this is through religion which allows the illusion that if it was not our own mind which created the world, then it was, at least, some other mind, generally benevolent to ourselves. And then, of course, there is art . . . Disjunctured as the human infant may be from function and necessity, the growing child (by reason of the evolution of hand and brain) manifests exceptional capacities to act on the external world. As the child abandons the illusion of omnipotence, one of his most important transitional compensations comes through *play*. Even when as an adult he is constrained to relate to reality immediately and functionally, through work, for the purposes of survival, he finds (at least if he lives in an aesthetically healthy society) that he is compensated by the persistence of a creative, imaginative, and aesthetic component in his every day labours. As Edmund Leach, the social anthropologist, once put it: 'Each of us is constantly engaged almost from birth, in a struggle to distinguish 'I' from 'other' while at the same time trying to ensure that 'I' does not become wholly isolated from 'other'. And this is where art comes in. It is the bridge we need to save ourselves from schizophrenia.' Indeed, one might say that rhythm, pattern and the decorative arts draw upon feelings of union and fusion; whereas carving, figurative painting, and the proportional arts of architecture are rather expressive of separation, and the recognition of the 'other' as an objectively perceived feature.

But we have to remember that once, art was not a category set apart: the aesthetic dimension permeated all human skills; the potential space was held open within the

everyday pursuits of ordinary men and women. But, for this to happen, the environment must be as facilitating as the mother once was: in particular it must provide appropriate materials and a living stylistic tradition. Through working upon these everyone can thus simultaneously express his individuality, and affirm his identity with the shared symbolic values of the group. In this way, the insult of the Reality Principle is softened, and human creativity unleashed.

Perhaps I could clarify my concept of an aesthetically healthy society through referring to aboriginal art. In traditional aboriginal societies, we find the most rudimentary form of aesthetic activity—body painting and adornment—associated with ritual, rhythm, and the affirmation of shared religious beliefs. But we see, too, how ornamentation is extended from the body to the non-functional (except in a symbolic sense) transformation of environmental features like rocks, trees, and shells: these activities merge into pictorial representation. Nonetheless, in aboriginal culture, there are no clear boundaries between art and other forms of work. The aborigines decorate many of the things they make: naturalistic and geometric designs proliferate over paddles, spear-throwers, boomerangs, baskets, shields, message sticks—and all manner of every-day objects. Their forms are often determined not just by practical function, but also through symbolic intent, and attention to the aesthetic qualities and properties of materials used. But, as far as we know, there were no professional artists among the aboriginal tribes. Everyone participated in artistic production; or, to be more precise, art was a dimension of everyone's productive life. But this never meant that the aesthetic dimension sunk to the lowest common denominator. Unevenness of ability was recognised; those who showed exceptional artistic talent tended to be specially encouraged.

The fundamental elements of the 'aesthetic dimension', then, include instinctive aesthetic sensations; and imaginative and physical work on materials and stylistic conventions as given by tradition. Through engagement with the latter, an individual's work enters into the 'symbolic order' of a society without losing its individuality. That, I think, is what Winnicott meant when he said there can be no originality except on the basis of tradition. Of course, the particular form the aesthetic dimension takes in any given society will depend on historical vicissitudes. But the problem is that in advanced industrial societies it seems almost as if 'the aesthetic dimension' has been hopelessly marginalised, and the 'potential space'—at least as the location of adult cultural experience—effectively sealed over. So what has gone wrong?

I must reach for the very broad brush again, this time to do some quick history painting. I want to argue that this aesthetic crisis has its roots in the disruption of the shared symbolic order, which began in the Renaissance; and the radical change in work which was brought about by the subsequent industrial revolution. If it were permissible to psychologise historical processes, I would say that, in the Renaissance, the 'structure of feeling' changed: emphasis shifted from a sense of fusion with the world (originally the mother) towards 'realistic' individuation, and recognition of its separateness. Science began to travel along those paths which eventually

led to the discovery that the world was not created by a feelingful mind well disposed to, and in effect a projection of, ourselves but was rather the chance product of natural processes. T. S. Eliot once observed that this led to a 'dissociation of sensibility' from which we are still suffering. From this time on, men and women were compelled to shift uneasily between an emotional participation in the world, and the pose that they were outside a system they could observe objectively. Predictably, in the Renaissance, the ornamental and decorative arts of fusion started their long decline; whereas mimetic and figurative arts leapt out of the decaying sub-soil of the crafts.

Soon after, these processes were accelerated by changes in the nature of *work*. I am sure no-one needs reminding that the eighteenth and nineteenth centuries, in Europe, saw the proliferation of industrial capitalism, the spread of the factory system, and the emergence of a 'working-class': these developments expunged the 'aesthetic dimension' from everyday life. The division of labour severed the creative relationship between imagination, intellect, heart and hand: in effect the 'potential space' began to shrink. The insult of the Reality Principle impinged deeper and deeper into the lives of ordinary people. There was no room for an intermediate area on production lines, at the pit-head, or in steel furnaces.

Inevitably, of course, in this situation there were those who yearned for what was being lost: John Ruskin, for example, put forward the paradigm of 'The Gothic'—which, in as far as it wasn't a purely historical category (which it never really was for him) was close to my concept of the 'aesthetic dimension', or Winnicott's idea of the 'potential space' as the location of cultural experience. Or, as John Unrau has recently put it, 'The Gothic', for Ruskin, was a mythological vision of 'what all human labour might ideally become.' Kristine Garrigan has written that for Ruskin a great masterpiece of Gothic architecture 'stands not only figuratively but also literally for the spiritually unified society in which each member's creativity however minor or imperfect is respected and welcomed.' Ruskin saw such a building not as a structural enclosure of space, but as 'a symbolic shelter for mankind's noblest aspirations'. This, of course, did not exclude individual expressive work—but rather drew it out. Thus Ruskin stressed how the Gothic system of ornament in 'every jot and tittle, every point and niche ... affords room, fuel and focus for individual fire.'

Although, in the nineteenth century, the 'aesthetic dimension' was compelled to retreat from everyday life, 'Art', of course, persisted. But it was no longer an element in man's lived relationship to his world: rather it became the pursuit of certain creative men of genius, who were set apart in the sense that they were not expected to bow to the inexorable dictates of an ever more tyrannous Reality Principle. 'The Arts in their highest province', Joshua Reynolds once said, 'are not addressed to the gross senses, but to the desires of the mind, to that spark of divinity which we have within, impatient of being circumscribed and pent up by the world which is about us.' The Arts thus became the special preserve for a dimension of imaginative creativity which had once pervaded all cultural activities. But the Artist could not, of

course, penetrate deeply into the productive processes and social fabric: rather his task increasingly became the creation of the *illusion* of what Marcuse called 'other realities within the existing one'. The painter had long since ceased to be primarily the decorator of architectural space, or functional objects like pots and boomerangs: rather, with the assistance of focused perspective, he became the creator of a painted world in an illusory space behind the picture plane: a human god, in fact. Aesthetic form acquired its autonomy from, and indeed opposition too, life as lived. As Ruskin so vividly put it, 'The English school of landscape culminating in Turner is in reality nothing else than a healthy effort to fill the void which destruction of Gothic architecture has left.'

But how, even in illusion, could the Fine Artist continue to fill that void given the long, withdrawing roar of the Sea of Faith? How, without a religious iconography, could the painter appeal beyond 'the gross senses'? Ruskin tried to show how Turner had studied nature so closely because through nature he found God: but such a pantheistic solution depended upon sustaining the belief that nature *was* that handiwork of God. And, as the nineteenth century progressed, the nakedness of the shingles of the world became more and more apparent.

When it seemed that nature could no longer provide a viable alternative for the lost symbolic order, the 'aesthetic dimension' began to disintegrate even in its illusory re-incarnation behind the picture plane. Art aspired to redeem itself through submission to the Reality Principle (in naturalism, impressionism, etc.). Or, alternatively, in the aesthetic movement of the late nineteenth century, it sometimes tried to reduce itself to the pleasure to be derived from the stimulation of residual aesthetic instincts through looking at certain combinations of colour and form. Ruskin called such merely sensuous pleasure 'aesthesis' and predictably expressed contempt for 'the feelings of the beautiful we share with spiders and flies.' This was at the root of his notorious quarrel with Whistler and Modern Art 'under the guidance of the School of Paris'. But the esotericism of such movements as Symbolism could provide no consolation for the loss of a shared symbolic order. Not surprisingly, even in the nineteenth century, the artist sometimes felt himself to be menaced by a darkling plane of General Anaesthesia. As nature seemed to become drained of meaning and feeling alike, art itself seemed threatened. Significantly, as Ruskin's own religious faith waxed and waned, he found himself tormented by an obsession with a failure in nature itself; he believed he could detect an evil storm cloud and plague wind in the landscape. A grey shroud, which he associated with the blasphemous actions of men, seemed to be descending on the world portending ultimate annihilation. At such times, he could not bear to gaze even upon his beloved Turner's, and he ordered them out of the house.

Others described the aesthetic crisis in different ways: William Morris predicted that the divorce of the High Arts from a living tradition of creative work in the crafts would lead to the death of architecture, sculpture, painting, and the crowd of lesser arts that belong to them. He foresaw what he called 'this dead blank of the arts'. 'If the blank space must happen', he wrote, 'it must and amidst its darkness

the new seed must sprout.' I am trying to suggest that the 'dead blank' was in fact realised in Late Modernism ... and that, just possibly, what I have been calling 'Post-Modernism' is the sprouting of a new seed.

I cannot do justice to the history of Modernism here but don't worry! I'm not Robert Hughes—so I won't even try. I just want to emphasise that, however uneven its development, whatever individual triumphs there may have been on the way (and there were many) Modernism completed this draining away of the aesthetic dimension even within the arts themselves. This can be seen taking place in Late Modernism, by which I mean (roughly speaking) 'mainstream' post second world war art. Art severed itself from the 'cosmos of hope'; it ceased to offer 'an other reality within the existing one', or a miniature realisation of the 'potential space'. Rather, it began to reflect that squeezing out of a cultural space for imagination, individual subjectivity, and expressive or affectively satisfying work. I want to illustrate my argument by saying something about two strands within the fragmented Modernist tradition: functionalist architecture, and abstract painting.

Take modern architecture: now we have seen how Ruskin rightly regarded good ornament as the means through which a building aspired to the aesthetic dimension, and entered into the shared symbolic values of the community. He also saw it as the guarantee of the creative work of the individual workman. But, of course, nineteenth century mechanisation of ornamental features wrecked all this and reduced ornament to stuck on effects. At the beginning of the twentieth century, Modernist architecture arose with the credo that form should follow function, which, in effect, made the architect synonymous with the engineer, and endeavoured to sell out architecture to the 'Reality Principle'. But the pioneer Modernists had failed to recognise the distinction between the dead residue of the aesthetic dimension they were sweeping away and living ornament which as Ruskin again rightly put it is 'the principal part' of architecture as opposed to building.

Indeed, in 1908, Adolf Loos, a pioneer of Modernism, published a paper called 'Ornament and Crime' rejecting all the decorative arts (including the 'babbling' of painting) on the grounds that they were erotic and involved unproductive work. Ornament, Loos argued, was OK for children, criminals and primitive people. Children like scrawling on lavatory walls; 80% of prisoners bear tattoos; 'and the Papuan tattoos his skin, his boat, his rudder, his oars; in short, everything he can get his hands on.' (Remember what I argued about aboriginal art?) But Loos claimed, 'what is natural for a Papuan and a child is degenerate for modern man'. Thus he declared, 'I have discovered the following truth and present it to the world: cultural evolution is equivalent to the removal of ornament from articles in every day use ... Don't weep!' he said. 'Don't you see that the greatness of our age lies in its inability to produce a new form of decoration? We have conquered ornament, we have won through to lack of ornamentation.' He painted a picture—if that's an appropriate metaphor—of a new Zion for modern man in which the streets of the town would 'glisten like white walls'.

Ornament wasn't just regressive. It was also uneconomic. If there was no orna-

ment, Loos reasoned, 'a man would have to work only four hours instead of eight, for half the work done at present is still for ornamentation. Ornament is wasted labour.' Loos was especially critical of 'stragglers', i.e. 'modern men' who gave in to a liking for a little decorative stitching on their shoes, a patterned wall-paper, or frill of lace. Stragglers, he said, 'slow down the cultural progress of nations and humanity, for ornament is not only produced by criminals; it itself commits a crime by damaging men's health, the national economy and cultural development.'

The only decorative elements Loos permitted were materials deployed for their given qualities: no symbolic or expressive transformation was allowed. Similar sentiments proliferated among all the 'pioneers'; their followers implemented the anti-ornamentalist programme with the ruthlessness of converts. Modernism sought, in Lubetkin's words, to assert itself against 'subjectivity and equivocation'. Synthetic and unaesthetic materials, engineering methods, standardisation, and repetitive rectilinear forms triumphed in the advance, from the 1930s onwards, of the anaesthetic International Style. 'The individual,' wrote Mies van der Rohe with ominous glee, 'is losing significance; his destiny is no longer what interests us. The decisive achievements in all fields are impersonal and their authors for the most part unknown. They are part of the trend of our time towards anonymity.'

Now we have seen the new Zion in which the only worthwhile labour is immediately productive, ornament is banished and people inhabit not houses but 'machines for living in', and it does not work. Where, in all that dead expanse of curtain wall, is there an inch of space for symbols and values beyond the demands of function and necessity? Where, in all that cantilevering, is there any 'room, fuel and focus for individual fire'? Ruskin prophesied the hell we made for ourselves. 'You shall draw out your plates of glass,' he wrote 'and beat out your bars of iron, till you have encompassed us all ... with endless perspectives of black skeleton and blinding square.'

All right, now abstract painting: I believe Modernist painting manifests a progressive *kenosis*. That's a term I've borrowed from theology: it means a voluntary relinquishment of divine power. Painters simply renounced their capacity to create illusory worlds. Thus within Modernism, perspective space and the imitation of nature fade, and there is a surge of emphasis on painting's roots in decoration and sensuous manipulation of materials, and a belief that such elements could provide a replacement for the lost symbolic order, destroyed by the decline of religious iconography, and the subsequent 'failure of nature' to provide a substitute. Some great works were produced this way. Kandinsky, for example, replaced the pathetic fallacy with the art fallacy: the belief that abstract forms and materials could palpitate with his spiritual sentiments.

But Clement Greenberg once pointed out that Kandinsky's art continued to evoke landscape and even flower subjects: 'The atmospheric space in which his images threaten to dissolve,' Greenberg wrote, 'remains a reproduction of atmospheric space in nature, and the integrity of the picture depends on the integrity of an illusion.' Late Modernism was to lose all those residues of nature, and that illusion of

natural space, in an attempt to use pure colour and form as the sole means for the expression of high sentiment. The greatest painter of that kind was Mark Rothko who created undulating fields of nuanced colour. 'I'm not an abstractionist.' Rothko once said. 'I'm not interested in the relationship of colour or form or anything else I'm interested only in expressing basic human emotions—tragedy, ecstasy, doom and so on.' Rothko added that people who wept before his pictures were having the same religious experience he had when he painted them. 'And if you . . . are moved only by their colour relationships,' he said, 'then you miss the point.'

The danger, however, was not just that the audience might 'miss the point': the sentiment, itself, might be swallowed up by the 'negative space' Rothko was creating, leaving, as it were, a 'black hole' where once the painter had offered an alternative world. 'Art,' says Hans Kung, the leading Catholic theologian, 'is seen . . . no longer against a pantheistic but *against a nihilistic background.*' Kung says this raises the question of art and meaning in a wholly new and ultimate radicalness. He invokes Nietzsche's images of nihilism: 'The sea drunk up (a bleak emptiness), the earth unchained from its sun (an abysmal nothingness).' Atheist as I am, I believe Rothko was the great master of this ultimate radicalness. In his art, he returns us to the ground of our being where we may choose extinction or re-engagement with reality in a new way. But Rothko's painting was not just a protest against the anaesthetisation of contemporary 'culture': he was also a victim of that process. He chose extinction. You can see that choice in the last paintings he made before his suicide.

These pictures are grey monochromes, in which colour and pictorial space, alike, have drained away. They are not elevating expressions of despair on the threshold of death—like, say, Poussin's great grey painting of *Winter* or *The Deluge*. They, themselves, are empty, *dead*. The redeeming power of anaesthetic transformation has gone. This is what I mean by anaethesia. In gazing at these works we think of Lear's utterance, beyond tragedy, beyond hope: 'Nothing, nothing, nothing, nothing, nothing.' In these monochromes, Rothko's high sentiments collapsed into the 'blinding square' and 'dead blank' of anti-art. Within a few months, he himself lay dead in a pool of blood on his studio floor.

After Rothko's ultimate painting, most abstract art betrayed the 'aesthetic dimension'. Either it pursued mere aesthesis, or sensuous effects—as in the 'Post-Painterly' abstraction of Morris Louis, Ken Noland, etc. Or it relinquished art in favour of the real—which, we remember, according to Winnicott was the 'arch enemy' of creativity. For example, I remember a large exhibition of 'minimal' art which came to London, from New York in 1969—the year Rothko was painting those grey pictures. In fact, it included a Rothko as a precursor of the new 'Art of the Real' (the title of the exhibition,) which included endless square monochromes and cubes, and, of course, Ad Rheinhardt's all black painting. But the attitude the exhibition expressed about art was the inverse of Rothko's. A statement in big letters on the cover of the catalogue said: 'Today's real makes no direct appeal to the emotions, nor is it involved in uplift, but instead offers itself in the form of the

simple, irreducible, irrefutable object.' There we have it! Art was no longer a 'transitional object', a mediator between the real and the 'cosmos of hope', but rather a mere *thing*, indistinguishable from other phenomena. As the catalogue put it, 'The new work of art is very much like a chunk of nature ... and possesses the same hermetic otherness.' Thus, in this *reductio ad absurdum* of Modernist 'truth to materials' that creative 'moment of illusion' which good art provides was utterly extinguished; the potential space was sealed over even within the practice of painting itself. Just a few years ago, I counted up and found I knew seven painters in London who were making nothing but blank, grey monochromes. At that time it seemed that painting, too, had simply succumbed to the General Anaesthesia of our time.

Of course, while ornament was disappearing from architecture, and this terrible *kenosis* of painting was taking place, new means of producing and reproducing imagery were proliferating: indeed, the Fine Arts had become only a small strand in what I have called elsewhere, 'the mega-visual tradition' of monopoly capitalism. Here, I am referring to such phenomena as photography, mass-printing, bill-boards, neon signs, television, video, holography, and so on with which we are constantly surrounded. But I believe it is wrong to regard such things as the mode of the aesthetic dimension in our time: rather, like the mechanical ornament of the nineteenth century, they represent only its occlusion and eclipse.

I am sure the Victorians were right. Whatever photography may be, it is not art. A photographic image is mechanically processed—not imaginatively and materially *constituted*. The photograph clings to the appearances of the real, which is why it can be an excellent tool when rapportage, or visual journalism, is required. But imaginative transformation of photographic materials, or images, is inimical to the practice. If the photographer tries to offer the kind of experience we get from an image of an angel or an undulating plane of colour, à la Rothko, he will certainly end up with a bad photograph. The sophisticated techniques of modern advertising, however, seem in some ways closer to the 'aesthetic dimension' than straightforward photography. There are, as it happens, angels in certain bath salt advertisements! Again, advertising takes everyday materials—like soap, beer, or tobacco—and through imagery associates them with our imaginative longings for a world transformed according to our wishes. But this is prostitution where art is love. Unlike a religion, the symbolic order within which the advertisement is articulated, is cynically displaced from deeply held feelings or values; the transformations of the real we can perceive in an advertisement occupy a shallow and attenuated 'potential space', massively impinged upon by economic interest. Who actually believes that drinking Coke rather than Pepsi will bring about peace on earth? Or that using one brand of detergent rather than another will deepen family love? But, of course, it is not just *what* is shown; it is the way the images are made that bear witness to their inauthenticity. Unlike a painting, an advertisement does not offer a paradigm of what all work might ideally become; although advertisements have displaced ornament, in no sense are they an equivalent for a true ornamental tradition through which each

individual's creativity can be welcomed and realised. The advertising system is just piped spectacle, a sad travesty of what art once was.

It was, I suppose, inevitable that the anti-aesthetic practices of this mega-visual tradition would invade the anaesthetic space—the blank squares—left by the disappearance of the true arts ... That Pop Art, Conceptual Art, Political Art, video and mixed media, would swamp in over that emptiness brought about by painting's *kenosis*. Where once there was 'an other reality within the existing one', proffered through realised aesthetic form, now information, ideology, and the prostitute practices of the mega-visual world proliferate.

For example, I recently saw an exhibition called 'Eureka', which purported to offer a survey of contemporary Australian art. One half of it consisted of posters, installations, set-up photographs, etc. in which not the slightest residue of what I have been calling the 'aesthetic dimension' was discernible. Indeed, the imagery chosen again and again illustrated how in content, as well as in form, such work had committed itself not to the 'cosmos of hope' but rather to the pornography of despair. When it comes to making a choice between looking at, say, 'art' photographs of an 'artist' throwing up, and Oxo's image of a family smiling blissfully around the stew-pot, then I must say I prefer the latter, even though I'm not very interested in either.

Predictably, the theorists are flooding forward to justify the spreading anaesthesia. Just as in the nineteenth century's aesthetic crisis there were those prepared to say that the aesthetic dimension in man was nothing more than instinctive response to retinal sensation, so, in the twentieth century, as that crisis deepened, there was no shortage of those—from logical positivists, to Althusserian Marxists and structuralists—happy to come forward and argue that there was *no such thing* as aesthetic experience at all. For example, a whole breed of British sociologists of art are now telling us that such words as 'artist', 'creation', 'imagination', 'work of art', etc. are just hang-overs from Romantic ideology which need to be erased in favour of such terms as 'cultural producers' and so forth. But I have tried to show you that the vocabulary of art, artists and aesthetics only appears obsolete today because a great dimension of human life and experience is presently catastrophically threatened.

Marcuse once argued that, in our time, the reality principle had become metamorphosed by advanced technology and monopoly capitalism into a tyrannous 'Performance Principle', which was suppressing and distorting a biologically given potentiality of our species for play, creativity, and pleasure. In my Winnicottian terminology, it might be said that today, we are producing a Reality Principle without the redemption of a 'potential space', and that is an insult to us all. I have tried to show how, as it were, the potentiality for a 'potential space' arose in our natural history, as a species; and how, after many historical vicissitudes, it is now perilously threatened. But how much hope are we justified in placing in that apparent resuscitation of the aesthetic dimension which I began by drawing your attention to: i.e. the revival of painting, sculpture, the imaginative and decorative arts, and the whole range of crafts pursuits and practices?

In one sense, it is easy to see that such phenomena represent a desperate attempt to hold open the 'potential space' in our time. But, by its very nature, the aesthetic dimension can only thrive within such a space given a socially given aesthetic *style*; good art can only be realised when a creative individual encounters a living tradition with deep tendrils in communal life. But given the present class divisions, systems of production, and, in the West, the mega-visual traditions to which these give rise, no such style exists: nor is it easy to see how it could exist. For example, in our art schools in Britain, until the changes of the last three or four years, it seemed that there were only two sorts of student: those who took as the paradigm for artistic activities the 'pre-cultural' activities of the child—and engaged in slurpy abstraction, and such like; or those who took their model from the anaesthetic practices of the mega-visual tradition, and replaced art with media studies, photo-texts, video, etc. Because society was so aesthetically sick, there seemed no avenue through which the biologically given potentiality for aesthetic production could be realised in an adult, social way, as in, say, aboriginal society, or Ruskin's concept of Gothic. The student artist had to choose between infantilism or anaethesia. Hence the limitations of 'The New Spirit in Painting'.

But the problem can be seen in its most extreme form in architecture now that the anaesthetic anti-style of rectalinear functionalism is under such widespread pressure. As we have seen the enabling and yet resistant forms of, say, Gothic architecture, within which the craftsman worked, sprang out of shared symbolic beliefs: but today, when the architect decides Loos was wrong, where is he to turn for his ornamental language? If he decides he wants something more than aesthesis—or sensuously attractive colours and patterns—he can *either* fall back on individual fantasy, à la Gaudi, or, alternatively, he can turn to the debased symbolic orders of advertising and spectacle. But the electric profusion of 'The Cross' at the other end of William Street in Sydney, Times Square in New York, or Piccadilly Circus in London, will never equal the level of human achievement manifest on the West front of Chartres Cathedral, nor can any number of buildings in the shape of Oxo cubes, hot-dogs, or hamburgers console us for the loss of an ornamental style rooted in sincerely held symbolic beliefs. The only other solution seems to be an eclectic borrowing from ornamental styles of the past: hence 'Post-Modernist Classicism'; but this is to use ornament with about as much sensitivity and meaning as a parrot uses words.

Neither the anaesthesia of functionalism, nor a wallowing in subjectivity, nor prostitution to the symbolic orders of advertising and spectacle, nor yet a parading of the ornamental clothes of the past can cover the fact of the crisis of the 'aesthetic dimension' in our time. Is there then no hope? Winnicott once pointed out how in an individual human subject creativity often seems almost indestructible, despite appallingly unpropitious environmental conditions. As the embryonic plant reaches for the light, creativity can twist into life and redeem the most 'hopeless' of individuals. It may be that the present aesthetic revival is the beginning of such a process within the social fabric itself. Such parallels are, I know, dangerous: but, in this case, the

proposition is not entirely unsupported by sociological evidence. As I've argued else-where, I think there are at least grounds for hoping that the future may give rise to a two-tier economy in which, as it were, automated industrial production will con-tinue to develop *alongside* aesthetic production: although, of course, for the poten-tial space to be held open in any significant way, the latter will have to be incorpor-ated into our productive life in a much more radical way than that permitted by leisure, hobbies, or the Fine Art enclave itself. All I can say is that I had *better be* right about this. I agree with Gregory Bateson, the anthropologist, who once said that the passing of belief in the immanence of God within nature was leading men to see the world as mindless, and hence as unworthy of moral, ethical or aesthetic con-sideration. Although, like Bateson himself, I am an atheist, I think he got it right when he said that when you combined this alienation from nature with an advanced technology then 'your likelihood of survival will be that of a snowball in hell.' Bate-son spoke of the need for a new aesthetics, rooted, as he put it, in 'an ecology of mind'—or the recognition that if nature is not the product of mind, then mind itself is in some sense the product of nature—and is therefore immanent within the evolu-tionary structure, and objectively discernible outside of ourselves. In the 'grammar' of the genetic instructions which inform the leaf how to grow, or the 'beauty' of the patterns on the wings of a butterfly, we see prototypes of man's highest endeav-ours—even if we do not believe in God. I think that the great British painter, and pioneer Post-Modernist, David Bomberg recognised this when he urged artists to seek 'the spirit in the mass.' And it may be that those who are currently seeking to re-root aesthetics in the study of nature and natural form, in ways which go beyond empiricism, and which nonetheless absolutely refuse explicitly religious connota-tions, are unwittingly playing their part (however small) in arresting progress towards that General Anaesthesia implicit in the development of our technological society. Of course, that Anaethesia is not just a blank grey monochrome on canvas: it is, as Ruskin foresaw, the annihilation of human life, and nature itself—some-thing which the modern technology of nuclear war has rendered not just an histori-cal possibility, but rather a probability. And so I would like to end by recalling the biblical words: 'Art, I believe: help thou mine unbelief.'

Art in 1984

The subject I have chosen for my lecture is 'Art in 1984'; or it could, I suppose, have been sub-titled, 'The Positive Politics of Good Decoration'! When I was last in Australia, my lecturing style was compared to that of a 19th century preacher. So I thought I'd start off this evening with a text which comes, appropriately, from the Ninth Section of the Second Part of George Orwell's 1984. For those of you who know the plot it's from the passage describing Winston Smith's exposure and arrest; as for those of you who don't . . . All will become clear, I hope, in a minute. Anyway, here it is:

There was another crash. Someone had picked up the glass paperweight from the table and smashed it to pieces on the hearth-stone.
The fragment of coral, a tiny crinkle of pink like a sugar rose-bud from a cake, rolled across the mat. How small, thought Winston, how small it always was!

The smallness of the space for art in 1984 was brought home to me recently when a frightening document, marked 'Strictly Confidential', and headed '"New Outlook" For Royal College of Art' came into my hands. For those of you who do not know, the College is the pinnacle of the art education system in Britain. What happens there affects the way art is taught throughout the United Kingdom, and indeed, much further afield than that. This report, commissioned and endorsed by the then Rector, called for wide ranging expansion of the activities of the 'Visual Communications Faculty', leading to a new approach for the whole institution.

For example, it was suggested that a glittering new department for the so-called 'Electronic Arts' should be set up within the restructured Faculty, offering courses in computer graphics, electronic typesetting and something called 'text manipulation', with a supporting staff of at least six software engineers. Such a department would be the first of its kind in Europe; linked to a School of the Moving Image, it would replace the now apparently obsolete School of Film and Television. All members of the Faculty would undergo a compulsory course 'on the way business works', bolstered by subsidary courses in advertising, packaging and marketing.

Ominously, it was said that the Faculty should continuously review the perfor-

17

mance of all its staff in the light of developments in new technologies; 'initiate research-based commercial ventures in collaboration with industry'; and research the market with a view to establishing any course—the phrase is theirs—which could be 'run profitably'.

Soon, I imagine, advanced students of the Visual Communications Faculty will be reading for PhD's in Pornography. Well, I'm sure pornography could be very profitable. But I searched the document in vain for any mention of painting, sculpture, or the traditional crafts. Indeed, the rumour was that the Painting School was to be shunted off to the wilderness of West London, while the gleaming new Visual Communications Faculty was erected on a prime central site. Nor could I find any reference to those aesthetic values which the College once so produly defended. Fortunately, the Rector responsible for this piece of Newspeak has been forced to resign. But the battle is not won. Indeed, a so-called Datec system is replacing the old Foundation Courses for those entering art education after leaving school. The object of Datec is, as they say, to channel more and more students towards 'meeting the needs of British industry'. Art is beginning to be squeezed towards the very margins, even within the art education system itself!

'How small, thought Winston, how small it always was!'

In Europe, at least, 1984 was so endlessly imagined and anticipated that it was in danger of becoming a bore of a year even before it had begun. By September 1983, *1984*, the book, was selling 100,000 copies a month in Britain and 50,000 every day in the USA. You could hardly open a newspaper, switch on TV or the radio, without the name, 'Orwell' streaming out at you a dozen times.

I have no desire to swell this torrent of Orwelliana. But it is essential to my argument that you have some idea of the sort of world he depicted, and the role art played, or rather did not play, in it. If you've recently re-read the book, I hope you'll forgive me ... *1984*, first published in 1949, depicts the world divided into three great powers between whom there is perpetual hostility, but a shifting pattern of offensives and alliances. The narrative takes place in Oceania consisting of what used to be the Americas, Britain and Australasia. The Party—whose ideology is known as Ingsoc, claiming descent from English Socialism—is in absolute control. It rules through agencies like Minipax, or the ministry of Peace, which is entirely concerned with the pursuit of perpetual war. The hero of the novel, Winston Smith, works at Minitrue, the Ministry of Truth, which puts out an endless stream of lies and propaganda and literally rewrites history. After Datec, Winston might well have taken a course in 'text manipulation' at the Royal College!

In Oceania, society is divided into three classes, the Inner Party, Outer Party and the Proles, who are virtually animals and play no part in political life. The Inner Party devotes most of its energies to trying to achieve absolute control over the lives of those in the Outer Party. All actions and words—indeed every aspect of human subjectivity—are monitored through an elaborate technology of telescreens and hidden microphones. Big Brother is watching, all the time. Even wearing an improper expression on your face is a punishable offence—or 'facecrime'. Worse still

is 'thoughtcrime'. Orthodoxy is relentlessly enforced by the Thought Police attached to Miniluv, the Ministry of Love.

Now Orwell shows us only the residue of anything that might be called art or culture surving in 1984. In Oceania, the richness of language is becoming progressively debased into official Newspeak. The great literature of the past disappears as it is translated into this bland, impoverished, and colourless tongue. Meanwhile, at the Fiction Department, novels are written by machines; and Prolefeed—'rubbishy entertainment and spurious news'—is churned out for the masses.

The visual and architectural arts fare no better. Some buildings have been constructed in a confident, technist idiom. Minitrue is housed in 'an enormous pyramidical structure of glittering white concrete, soaring up . . . 3,000 metres into the air'. But this is exceptional.

The early 20th century vision of 'a glittering antiseptic world of glass and steel and snow-white concrete' has come to nothing. Oceania, for all its technological sophistication, is a dingy, listless tackey sort of place. One reason for this is that science and technology are entirely bound up with the pursuit of death, in the wars, rather than life. Vile films, focusing on such things as 'a wonderful shot of a child's arm going up up up right into the air', and smut, officially produced by Pornosec for consumption for Proles only, proliferate . . . but nothing aesthetic, ornamental, or beautiful remains.

Or almost nothing. When Winston's soul begins to protest against the system, he discovers a run-down junk-shop where a man called Charrington sells old lacquered snuff-boxes, agate brooches, and so on. Charrington turns out, in the end, to be an agent of the hated Thought Police, who uses these aesthetic objects to entice rebels. The price of such things is falling, because the *good* citizens of Oceania simply are not interested in them. Winston first buys an antique, young lady's keep-sake album, in cream-laid paper, of a kind that has not been made for more than half a century. He uses it as a diary, in which he finds he is able to express himself verbally for the first time; later, at the same shop, he buys a beautiful glass paper-weight, which, Orwell tells us, possesses 'a peculiar softness, as of rainwater, in both the colour and the texture of the glass'. Embedded in the middle of it is that piece of pink coral. Winston's response to the paperweight is associated with the awakening of all his suppressed sensibilities, and potentialities.

For the moment, let us leave Orwell's *1984* just there; by one of those curious coincidences, 1984 also happens to be the 150th anniversary of another great, British dreamer about the future: William Morris. Although no one, clearly, is going to touch Orwell in his benefit year, only Morris has any hope of running even a close second! Everyone who is anyone seems to be claiming Morris for themselves. When I left London, a large exhibition, 'William Morris Today', was opening at the Institute of Contemporary Arts; there—unbelievably—you could enjoy a 'computer graphics tour of Red House'. You could also hear seminars by distinguished persons on such subjects as 'Useful Work, Useless Toil: the Post-Industrial Ethos'. Every shade of opinion on the left has rediscovered Morris and is seeking to rehabilitate him.

For some time now, Morris has been given respectable Marxist credentials. But our Labour establishment is starting to look at him again too. Neil Kinnock, the Labour Party Leader, opened the ICA exhibition while over at Congress House, headquarters of the British Trades Union Congress, there was a symposium on 'William Morris: his relevance today', addressed by the Assistant General Secretary of the TUC. But it isn't just the organised Left who is looking to Morris again. Not wishing to be left out, Margaret Thatcher recently announced that Morris was an inspiring example to us all of what could be achieved through private enterprise. She had in mind his 'small businesses' in the crafts, and his thriving retail outlet in London's West End. So what sort of world did Morris envisage? And why is everyone talking about him in 1984?

Morris laid out his vision of the future in a book called *News from Nowhere*. It could hardly have been more different from George Orwell's nightmare. For Morris offered a *positive* utopia, or a vision of 'the present rest and happiness of complete Communism' after a 'Great Change' had occurred in—according to his vision—the 1950s, throughout Britain.

Morris depicts a world from which tyranny, oppression and exploitation have vanished. Indeed, Government itself has gone along with the monetary and political systems, and men and women are reconciled to themselves, each other, and nature. Even in Piccadilly, at the very centre of what is in fact today urban London, there are houses standing in carefully cultivated individual gardens, running over with flowers. Black-birds sing; cherry trees are laden with fruit . . . and so on. The inhabitants of this utopia live longer; look younger; do not know the meaning of unhappiness and regard crime as 'a mere spasmodic disease, which requires no body of criminal law to deal with it'.

Now a lot has been said about this vision, and more still will undoubtedly be said this year. But those who would assimilate Morris to themselves today—be they on the far left, the established left, the 'technist lobby', or in Margaret Thatcher's pocket—consistently seem to underestimate the single most striking fact about Morris's imagined utopia: and that is the unbounded relish in art, or 'the extravagent love of ornament', which Morris endlessly attributes 'this beauty-loving people'.

This is a theme Morris labours on page after page. The first person whom the visitor meets when he arrives in the dream land is Dick, who works as a waterman. Dick wears 'a brown leather belt round his waist' decorated with a 'clasp of damascene steel, beautifully wrought'; his friend sports a 'golden spray embroidered on the breast', and a belt of 'filigree silver-work'. We hear too of the Golden Dustman of Hammersmith, while a pile of clothes shed by a gang of road-menders gleam with gold and silk embroidery. The ornamentation on such things as lead-glazed pot-ware, and even a tobacco pipe is meticulously noted. As for architecture . . . houses and public buildings alike are handsomely built and ornamented: *News from Nowhere* shimmers on every page with descriptions of friezes of figure subjects in baked clay, frescoes and gorgeous mosaics.

Art, in other words, abounds: and Morris sees it as integral to the happiness of those who live in his Utopia. Indeed, the very word 'art', he tells us, has begun to disappear because it has simply become 'a necessary part of the labour of every man who produces'. Machines, however, have not been banished; nor has technological development ceased. 'All work which would be irksome to do by hand,' we learn, 'is done by immensely improved machinery.' But machines and technology keep a low profile—more like that of menial servants' than gods! They interest neither Morris, nor the inhabitants of his imaginary world, except in so far as they allow men and women to enjoy the real business of creative and imaginative work, as exemplified in sound ornament. Indeed, as one of the inhabitants puts it—and let all those who want Morris on their side take careful note—'the energies of mankind are chiefly of use to them for (ornamental) work; for in that direction I can see no end to the work, while in many others a limit does seem possible'.

Remember the sort of thing the 'energies of mankind' were chiefly devoted to in *1984*? Remember Winston Smith's small but beautiful ornamental object, his paper-weight in soft glass, in which was embedded a crinkle of coral from the Indian Ocean? What was the significance of that object? I think it stood for something that had been lost—socially and personally. At one point Winston protests that the past has been abolished. 'If it survives anywhere,' he says, 'it's in a few solid objects with no words attached to them,' like the paperweight. But it also stands for his sup-pressed potentialities in the present, for what might be for him in another sort of world ... When Winston is first followed by Julia, he believes her to be from the Thought Police and fantasises about smashing her skull in with the paperweight. Later, they become lovers, and the glass object is always there in the room where they make ecstatic love. Winston associates it, too, with a dream of his whole life stretching out before him, 'like a landscape on a summer evening after rain', and with memories of fusion with his mother. When he and Julia are exposed and arrested, then the paperweight is shattered—according to our text.

The aesthetic or ornamental dimension of human life, which exists in Orwell's *1984* only as this hopeless residue, is precisely that which abounds and flourishes in Morris's *News from Nowhere*. Morris's utopia is, in fact, Winston's dream of living inside the paperweight realised. In *News from Nowhere*, celebration of the orna-mental dimension is associated with a 'second-childhood' of the world in which the promise of child-like play is fulfilled in imaginative adult labour. Those of you who have heard me lecture before will know immediately what I mean if I say that the paperweight in *1984* is the last refuge of 'the potential space', or the location of cultural experience in a world that had otherwise eliminated it entirely.

But let me make one point clear, I am *not* trying to say we live in 1984—at least not Orwell's! In Oceania, the dominant ideology is quasi-socialist; the dominant ideologies in the West today are those of the monetarist right. Although we have every reason to fear the repressive potentialities of the new technologies, surveillance and control have not yet reached the levels Orwell foresaw.

Nor do I want to imply that it would necessarily be 'lovely' to live in Morris's utopia. Much of what he says about human relations is sentimental hog-wash. I do

not believe we will ever see a society from which law, exchange, and Government have vanished altogether. Still less do I believe such a society would be a pleasant or happy one within which to live.

Nonetheless, we have every reason to feel uncomfortable about how much of *1984*, there is in 1984. Thirteen years ago, Raymond Williams compared the rhetoric for the British Labour Government's 'modernisation' programme with Orwell's Newspeak—not surprisingly since it was all done by Mintech, the Ministry of Technology. Since Harold Wilson's 'white-heat of the technological revolution' there has been a shift to the right: but this has only accelerated these ominous tendencies.

Doublethink abounds today in, say, NATO pronouncements about 'pre-emptive strikes', 'theatres of war', or a 'limited holocaust'. In Britain, the Tory Party *conserves* nothing. Our bellicose Boadicea holds a spear tipped with a nuclear war-head before her and happily presides over the debasement of our language, decay of our culture and traditions, and the erosion of hard won provisions for health and education. Meanwhile, culture is subjected to technological and commercial impingement at every level.

The imaginative dimension of childhood play is menaced by programmatic and computerised activities. In British primary schools, calculators and electronic toys, like Pocket Simon, are taking the place of clay and paint. I find the spread of Datec in art education more sinister than 1960s Mintech; at least in the 1960s it was assumed the art schools would develop *alongside* the technological revolution. But today, Fine Art courses are being changed into technological travesties of themselves, or shut down altogether. Whatever residual decency was left in public service broadcasting now seems threatened by the proliferation of commercial 'Cable Television' which promises an outpouring of putrid sap, spectacle, Americana and other prolefeed which will make Orwell's Pronosec look like a shrine of High Culture. O'Brien, the interrogator in *1984*, talks about the elimination of art from Oceania; in 1984, our 1984, art is in danger.

The commitment of technology to war, death and destruction rather than to life, and its severance from any version of democratic process, which Orwell predicted, is already discernible. The beautiful countryside of Britain—the countryside of Constable, Gainsborough, Cox, Cotton and Crome—is currently being punctuated with Cruise Missiles, 'Theatre' nuclear weapons intended to contain a little 'Limited Holocaust' in Europe, while the Americans—who control Cruise—look on from the other side of the Atlantic. These missiles arrived with the connivance of successive Governments, Labour and Conservative, and without any vote ever having been taken concerning their presence by our democratically elected representatives. E. P. Thompson—the distinguished historian, anti-nuclear campaigner, and biographer of Morris—has coined a phrase for these bizarre processes and policies: *exterminism*.

We cannot, therefore, simply dismiss Orwell's *1984* as a perverse nightmare. Nor should we sweep away Morris's *News from Nowhere* as some frilly, lacey-cuffed fantasy. Yes, in many ways, Morris was an old-fashioned Victorian Marxist; but,

for Morris, revolutionary Marxism was never more than a means for bringing about a just society in which men and women would enjoy each other, art and labour. Those means have been discredited. But his ideas about art and work themselves remain relevant: they are rooted, as he always acknowledged, in Ruskin and an older English tradition of moral, ethical, aesthetic, and what we would call 'ecological' opposition to capitalism.

Socialism as it actually evolved, was not like Morris's vision. It was based as much as capitalism on an ethic of increased production. Practical demands were inevitably focused almost exclusively on economic, rather than qualitative arguments about life and work. But today, in the real 1984, that older Victorian critical tradition— with its love of the ornamental crinkle—is beginning to acquire a potentially modern, or, lest I be misunderstood, post-modernist look. For albeit in feeble and often highly confused pockets, we are seeing the emergence of new sorts of opposition to corporate technism—whether of its left or right varieties. These pockets tend to be conservationist, 'post-industrial', and ecological. They are concerned with the redirection of technological development, and the maintenance of peace, as necessary prerequisites for the survival of nature and culture alike.

For example, E. P. Thompson has pointed out how the recent writings of Rudolf Bahro are almost 'a reincarnation in modern dress of some of the essential preoccupations of William Morris'. Bahro, a sometime dissident Marxist in Eastern Europe, now believes freedom is not obtainable through intensive industrialisation. He says that, in our part of the world, capitalist exploitation is no longer 'the decisive existential challenge to which people have to respond.' The rise of the workers as human beings 'no longer depends on their being able to consume more', but rather, as he puts it, on 'a new order for our entire life-process', on a transformation, both political and cultural, reaching right into our subjectivities, and personal capacities as human beings.

Though congenial and attractive, these new thinkers and groups can seem muddle-headed, impotent and cranky. Even Bahro seems recently to have lost his way . . . to have gone 'Orange'. One of their great weaknesses is that they do not seem to have an adequate, alternative ethical and aesthetic theory of human *work*, to replace the economic and technist one they are rejecting. And it is just perhaps here that this older English tradition of Ruskin and Morris can help.

Ruskin and Morris perceived that prior to the 19th century human production was, by and large, ecologically integrated. Indeed, work retained many of the features of organic or natural production. The things men and women made in a given society could be grouped into 'species' on the basis of ornamentation or function. But if you gather together, say, a group of traditional Nigerian oil jars from a single tribe, you will see at once you are confronted not with a repeated stereo-type, but rather with a series of clines. The jars affirm the relative cohesion of the tribe who made them—its identity in relation to other tribes; but they also seem to celebrate an infinite variety. Each jar is the product of an individual, and is as clearly distinguishable from other jars, even of its own kind, as the wing of one butterfly,

the skin of one lizard, or the whorl of one finger-tip is distinguishable from another.

But if such human production had continuities with natural production, it also had significant differences. The way human artifacts looked was determined through the exercise of such peculiarly human faculties as imagination and intelligence; and skillful manipulation of materials. The only analogy for human production seemed to be the creative activity of God in nature itself. In 18th century Britain, the word 'culture' came to describe this sort of specifically human—as opposed to natural or divine—productive work, which necessarily involved not only functional, but also individual, imaginative, symbolic and decorative elements. Culture was, however, eroded by the realisation that nature was not the handiwork of God, and battered by the spread of the factory system. It wasn't just that factory production imposed an 'unnatural' standardisation and uniformity in place of the 'organic' model; intense division of labour also pre-empted the creative use of imagination, intelligence and hands. The 19th century factories destroyed *both* the continuities of human work with natural production, *and* what was specifically human about human work, alike. The new industrial system tore art, the aesthetic dimension, out of labour and made culture effectively impossible for most of those who toiled.

Ruskin's importance today lies in the fact that he saw that the ethical and aesthetic objections to industrial capitalism—and not the narrow economic and political one pursued by Marxists and socialists—were primary; by this I mean he realised that if you pursued the latter without regard to the former you were likely to end up with a society more like Orwell's *1984* than like Morris's *News from Nowhere*. And this, of course, is what actually transpired, though in rather different ways, in the West and Soviet bloc countries alike.

There were, of course, those who *celebrated* the advance of the factory system on moral and aesthetic grounds: one of the first was Andrew Ure who, as early as the 1830s, argued that the factories would substitute 'mechanical science' for hand skill, so that all skilled labourers would eventually be replaced by mere over-lookers of machines. He thought this was one of the great benefits which 'physico-mechanical science' was bestowing on mankind. Such science was 'philanthropic', because it relieved the workman 'from niceties of adjustment which exhaust his mind and fatigue his eyes', and from 'painful repetition of effort which distorts or wears out his frame'.

Ruskin and Morris were opposed to the Ure position. They saw that the transformation of the creative workman into an operative was a degradation. Morris saw that in this situation culture necessarily became enclaved within the middle-class; it became, almost by definition, something the factory worker either could not engage in at all—or could only mimic in peripheral pursuits like horticulture, leisure painting or pigeon breeding. And as, he made his beautiful wall-papers, textiles, tapestries, and printed books, he realised that even there, in its enclave, cut off from 'real' productive life, culture could not hope to survive. And again, he was right.

Now you might have thought, mightn't you, that artists at least would have been

prominent in celebrating aesthetic, imaginative and cultural values, in conserving and elevating them as an alternative to the usurpation of creative life by machine. But the sad truth is that they were not. The dominant tendencies of the Modern Movement which emerged at the turn of the last century celebrated the blessing of mechanical production as the model for all human work. Indeed, the pioneer Modernists screamed their contempt for the creativity of the individual human subject, for improvisation, tentativeness, ornament, and nature alike.

But I want to emphasise that they—rather than Ruskin or Morris—were good, orthodox Victorians. The Modernists were just re-iterating the position Andrew Ure had put forward in the 1830s! Oh yes, it's true they often decked out their position with a lot of polemic about smashing bourgeois culture. But what was really so radical about that! After all, the development of the industrial system was flaying cultural and aesthetic life alive, and would have continued to do so quite effectively, thank-you, whether or not it received a little help from its Dada and vanguardist friends. Indeed, they made the silly mistake of thinking that because 'culture' had become a bourgeois preserve, it *ought* to be eradicated. Logically, this was no different from arguing that because health, happiness and comfort had become bourgeois prerogatives, health, happiness and comfort *ought* to be wiped off the face of the earth where ever they raised their ugly heads.

Here is a poem by Rodchenko, a prominent member of the Russian avant-garde still piously celebrated by many 'artists' and 'radicals' today:

Tell me, frankly, what ought to remain of Lenin
an art bronze,
oil portraits,
etchings,
watercolours,
his secretary's diary, his friends memoirs—
or
a file of photographs taken of him at work and rest,
archives of his books, writing pads, notebooks,
shorthand reports, films, phonograph records?
I don't think there's any choice.
Art has no place in modern life . . . Every cultured modern man must wage war
against art, as against opium.

Photograph and be photographed!

You may not like the Socialist Realism of the USSR. Neither do I. But let us be in no doubt. We have Rodchenko's word for it! If the avant garde had won out we would not have had better art in the Soviet Union. Rather we would have had no art at all. 'Art has no place in modern life.' But the 'radical' artists in the West were just

as philistine. 'Leave your head free for the demands of our age', runs one of the
Dada slogan poems:

> Down with art
> Down with
> bourgeois intellectualism
> Art is dead
> Long live
> the machine art
> of Tatlin
> DADA
> is the
> voluntary destruction
> of the
> bourgeois world of ideas.

Such anti-aesthetic vandalism was not peculiar to the Left. Take the Russian
Futurist, Marinetti. He thought that to admire an old picture was to pour sentiment
into a funeral urn, 'instead of hurling it forth in violent gushes of action and produc-
tiveness'. Predictably, on a visit to England, Marinetti urged his audience to, 'Dis-
encumber yourselve of the lymphatic ideology of your deplorable Ruskin ... with
his hatred of the machine, of steam, and electricity' and his mania 'for antique
simplicity'. He accused Ruskin of wanting to get back in his cot again. Such tech-
nism led, as it always does, to Marinetti's belief that every work of art must bear 'the
stamp of aggressiveness'. 'We will glorify war,' he wrote, 'the only true hygiene of
the world.' He was as good as his word. He went on to declare, 'War is beautiful
because it initiates the dreamt-of metalisation of the human body.' Marinetti
became a Fascist and helped to establish technist Modernism as the house-style of
Mussolin's Rome.

Nor, of course, was it just the Fascists. Last time I was here in Perth, I talked
about how the pioneer modernist architects throughout the West did indeed forget
the 'deplorable Ruskin'. They eradicated ornament, chased after standardisation,
mechanisation and the fiction that function can provide a substitute for style.
Modernism thus gave birth to those black skeletons and blinding squares Ruskin had
foreseen, to the anonymous inhuman terror of such places as the Rockefeller Centre
in Manhattan.

Or look at your own city of Perth! There are good buildings here, buildings, by,
say, George Temple-Poole and his associates, put up towards the end of the last
century. But this city has suffered more than most from this institutionalised vandal-
ism of the Modern movement. Temple-Poole's buildings look more and more like
Winston Smith's paperweight: little crinkles of attractive, historial ornament,
declaring other values, sandwiched between jaded and tacky pillars of towering
blankness.

You will remember that in *News from Nowhere*, Morris depicted the disappear-

ance of art through pervasion: no one noticed art as such because it had become un-leashed from its enclave and transformed itself into a dimension of productive life. Orwell, however, predicted the disappearance of art through a process of marginal-isation and obliteration. Art in *Oceania* was simply wiped out and replaced by the anti-art of advanced technology. Neither New York, London, nor Perth are yet like Oceania. We know that. But as you go home this evening look at your city again with its white concrete, curtain walls, and proliferating bill-boards and ask yourself which you seem to be shuffling towards: that richness of mosaics, carvings, paint-ings, ornament and peaceful aesthetic life in a garden city which Morris celebrated; or *1984*.

Of course, it isn't just a question of architecture: the machine age replaced man-made ornament with mechanical stereo-types. Our electrical age is replacing even these with mass-produced imagery of all kinds. This mega-visual tradition is swamp-ing and corrupting what little is left of art. In a sadly influential little book, John A. Walker recently observed, 'there is virtually no avant garde art in Europe, the USA and Australia which does not manifest the influence—direct or indirect—of the mass media.' Typically, Walker welcomes this fact, and goes on to praise what he chooses to call 'alternative artistic practices'—photomontage, the new Popism, Feminist art, Community art and so forth.

If you don't know what this alternative art is like, then go along to the Art Gallery of Western Australia—and you'll soon find out! For example, you can—so long as you are a consenting adult over the age of 18—cast your eyes on two pictures by Juan Davila, filled with borrowings from movies. Pop Art, adverts, traffic signs, and trashy pornographic magazines. Davila is hardly exceptional. This is the kind of thing that tends to get sent to Britain and America as 'Australian art'—as if we didn't have enough of it already! I am thinking, for example, of the all too aggres-sive 'mixed media' imagery of Mike Parr, included in the 'Eureka' show of Austra-lian art in London two years ago, and shown again alongside Davila in Paris last year. Like Davila's, Parr's work is simply too unpleasant to describe in any detail.

Walker provides the usual justification for this sort of thing. 'The aim of contem-porary art,' he says, 'is not to rival the mass media, but to subject them to a critical examination that will illuminate their ideological assumptions and representational mechanisms.' Leaving aside the issue as to whether this is what art ought to do . . . I don't think this sort of art actually does it at all. Davila's images seem in every significant respect like the sources on which they draw . . . except they have gone that little bit further, become that little bit nastier. Remember how Marinetti accused Ruskin of wanting to sleep in his cot again . . . Well here is an art quite literally unfit for children, which bears the 'stamp of aggressiveness' in every part, so that not only what it shows, but even the way it is made, seems enthused with that now all too dreamt-of 'metalisation of the human body'.

Their work reminds me, immediately, of those horrible official hate movies in Oceania where audiences watch 'a wonderful shot of a child's arm going up up up right into the air'. Pornosec, you may recall, was an arm of the Oceaniac state: but

the materials it produced were packaged and promoted *as if* they were the forbidden alternative. Popism, photomontage, a sort of perverse Feminist anti-art, Community Arts, and so on like to present themselves in Walker's phrase as 'alternative practices', somehow against the system. But this is often just doublethink. These things are an alternative to advertising and the mega-visual tradition only in the sense that they show us where we are likely to go, unless we do something now . . . The Royal College's Electronic Arts Department, for example, would proliferate these 'alternative practices'. They have already become an *art officiel*: they are the safe, easy preferences of faceless art bureaucrats who will readily confess to you in private that of course they do not personally like the stuff at all. Winston Smith didn't particularly like Newspeak when he worked at Minitrue.

But who does want this anti-art? This isn't *1984*. Happily we are not yet in a situation where Big Brother is forcefully imposing such noxious material on us from above . . . although that is how things may end up if we continue to allow this aggressive, dehumanising technism to pervade every aspect of our lives. Let us make it clear. We do not need an art that criticises the mass media by plagiarising their forms and practices. Such 'criticism' always ends up as collusion. We do not even need a New Expressionist art which reacts against the mass media with a splurging, nihilistic solipsism. Rather, we require an art which is affirmative of other values than these, of other ways of looking, living and making things, an art which is stamped not by aggressiveness, but with the indelible presence of an aesthetic dimension. We require patrons and administrators with the courage and executive power to commission, promote and nurture such a genuinely 'alternative practice'; while there is still time.

I do not underestimate the difficulties. The aesthetic dimension cannot readily thrive when the shared symbolic order, of the kind religion once provided, has been destroyed, but technology continues to develop as rapidly, aggressively and destructively as at present. As Gregory Bateson once put it, 'Most of us have lost that sense of unity of biosphere and humanity which would bind and reassure us all with an affirmation of beauty.' That's why we can't build Gothic cathedrals. But even Bateson—who, like myself, was an atheist—took some consolation in the fact that at least we were beginning to 'play with ideas of ecology'—even if we tend to trivialise them into commerce or politics. He was thus able to recognise some sort of 'impulse . . . in the human breast' towards recognition of unity with 'the total natural world of which we are.' A society which fails to nurture that impulse is lost; and herein lies the importance of the crafts and High Arts, regardless of how sophisticated technology may become.

The argument about crafts is the hardest to get over here in Australia. Australian white society has never had those great traditions of pre-industrial human workmanship we can still enjoy in Europe, workmanship which vividly expresses both the continutiy, and the uniquely human rupture with natural production which characterise true aesthetic work. You can't step out as I can from my home in Suffolk, walk just a few hundred yards into the outback to see flint flush-work and quatre-

foils and 15th century carved oak bench ends, or a magnificent angel roof in a medieval church, and wonder about why they don't make things like that now! Even the best Victorian revival work—which was often but a poor substitute—seems to have been razed, or otherwise rendered invisible, in Perth. No doubt because of this lacuna, many Australian white artists seeking to escape from the chains of Modernism look longingly at traditional aboriginal cultures, sometimes even seeking to elevate these nomadic peoples who mined their top-soil as being an exemplar of the ecologically sound life—for us! But I entirely agreed with Jill Bradshaw when in a penetrating article she wrote in Paris last year, she argued that a gulf which no act of the imagination can bridge divides traditional aboriginal culture from modern white society. William Morris could not have initiated a craft revival, let alone written *News from Nowhere*, if he had only had an aboriginal tradition to set against the factory system, and to use as the kernel for his dreams about the future. Aboriginal culture presents itself to us with an otherness which denies continuity or even imaginative emulation: which is why 'aboriginalisation' is bound to fail.

But the case of Australian painting, it seems to me, is rather different. It is true that Jill also saw your landscape painting of the 1940s and 1950s as another sort of 'escapism'. But here I would have disagreed with her. How I wish she was here so that we could have argued the point together. Let me explain. One of those things that interests me most is the way in which in 19th century England, a Higher Landscape painting emerged which offered an illusion of the reality which was being lost ... or an image of man reconciled to nature in which he found God. That was the basis of the early 19th century aesthetic which gave rise to the finest paintings in our history, those of Turner, and to the writings of John Ruskin, alike. It gave rise, in other words, to some of the severist criticism of industrial factory production. But this whole aesthetic, in practice and theory, collapsed with the discovery in mid-century that nature was not God's handiwork. You can actually see the drama being played out in the Pre-Raphaelite pictures of the 1850s: in the difference between Holman Hunt's celebratory, irridescent landscapes early in the decade, and the sour, despairing wasteland of his '*Scapegoat*' later on, where the nearest to God he could find was a mangy goat which dropped dead on him. The great moment of British landscape was over and it proceeded to decline.

Indeed, we have to wait almost a hundred years for anything comparable: and it happened here, in Australia. Now Jill criticised Nolan's depiction of the 'alien-ness of the desert void', and accused him of parasitising this landscape, of projecting into it his own anxiety in a negative form of the pathetic fallacy, of refusing to accept its intractable, unsignifying otherness. She even quoted Juan Davila against Nolan, 'The void of the land is forced to signify, ignoring the suture that it offers.'

I have always admired those early Nolan paintings greatly, and yet I have never been able to explain to myself quite why until I read what Jill had written. For me, it isn't that Nolan borrowed conventions from Europe that do not fit here. Rather, I think the Australian landscape provides a better metaphor for all of us, living in the shadow of Oceania than does the English idyll today. We know we have left the

garden of Eden—or rather; it is over-run with the metallic snakes of cruise—we live, all of us, and not just the Australians among us, on the periphery of a potential desert. We have become peculiarly ill at ease in the nature that nurtures us, constantly worried that through our own actions we will cause it to fail, certain that no God resides within the rocks and trees to save and console, sure that not much is for the best in this our only possible world. Nolan's stubborn refusal to accept the intractability of the Australian landscape, his insistence on articulating an aesthetic response to it, is not only something new and admirable in art: it also bears witness to that irrepressible 'impulse in the human breast' to affirm beauty in, and unity with, the natural world, *regardless*. It is perhaps the first example of the necessary new secular 'ecological' aesthetic. It was a tragedy that Australian art—with a few conspicuous exceptions—failed to build on the great moment of the 1940s and 1950s, and ended instead in the mire of false 'alternative practices' . . . I've no right at all to say this, but I feel sure that by the end of an evening's discussion, Jill would have agreed. At least in her fascinating work on the Fointainbleau painters, she shows that the consoling illusions of art are not just escapism.

Indeed, now that our culture has lost God, it may well be that it needs just such illusions if it is to survive at all.

How small, thought Winston, how small it always was!

Art & Post-Industrialism

I would like to start by taking you back to an exhibition that opened in London's Whitechapel Art Gallery in 1961. I was just fourteen at the time, and I was waiting with some trepidation to start my sentence in a minor English public school, something guaranteed to focus the mind wonderfully. My thoughts hardly dwelt on aesthetic issues all day long. Nonetheless, I can still remember the ripples of excitement which 'Recent Australian Painting'—as the show was called—caused even beyond the boundaries of the cultural press.

It was, I think, generally recognised that something significant, powerful, and original had arrived in East London from the shores of the antipodes. And there was even a foreword by Kenneth Clark at the front of the catalogue to prove it. Looking through that catalogue again today, it is easy to see that this must have been a remarkable exhibition—and a real challenge to the jaded British tastes of the early 1960s.

Painters of the calibre of Blackman, the Boyds, Brack, Dobell, Drysdale, Fairweather, Godfrey Miller, Nolan, Pugh, Tucker, Fred Williams . . . and many others were included. Most were unknown to British viewers. But these Australian landscapes depicting a strange and intractable terrain were self-evidently of compelling strength. And they were presented to us at a time when Britain's own landscape painting tradition had reached its nadir, and the hyping of American art fads—of various kinds of empty abstraction and Popism—was well under way.

Now both back home, down-under, and indeed abroad (in as far as they were known at all) most of these Australian painters were accused of *provincialism*. It was argued that their work was a product of Australian isolation—on the one hand from the civilising influence of a Renaissance pictorial tradition, and on the other from the invigorating currents of Modernism, especially in its latest anti-Renaissance, trans-Atlantic guises. Many critics in Britain thus sought to explain the power of the new Australian landscape painting by arguing that it was somehow brash, raw, innocent, from the edge of the primeval desert: aboriginal, almost.

Recently, I looked back over the published responses to this show and I found only one which argued strongly against this consensus—a lecture by Bernard Smith

called, 'The myth of isolation'. (This was later collected in the volume of his essays
which bears the title, *The Antipodean Manifesto*.)

Bernard Smith argued that, from around 1885 onwards, the pioneering figures in
the Australian tradition of landscape painting had been shaped and formed not so
much by isolation and ignorance—the negative aspects of 'provincial' vision—as by
a conscious and explicit *aesthetic conservatism*. These pioneers were well aware that
they wanted to defend and to develop certain traditional aspects of the European
tradition of painting; this involved them in a conscious, willed and *creative* refusal
of many dimensions of modernism.

'This desire to keep up at all costs with the international Jones's of the art of the
moment,' commented Bernard Smith, 'is in my view an infallible sign of the provin-
cial mind, of artists and critics, uncertain of what they are doing or where they are
going.' He added: 'Acceptance without question is the essence of provincialism.' A
healthy, indigenous tradition not only assimilates, it also rejects—otherwise it risks
become nothing more than 'a pale imitation of the metropolitan culture to which it
is affiliated'.

I don't think that there were many in Australia or Britain who—in the 1960s or
1970s—fully appreciated the implications of Bernard's argument. He was before his
time. Today, however, the destructive and corrupting effects of capitulation to a
decadent, American, Late Modernist culture are everywhere apparent. It is easy for
us to see just how right Bernard Smith was.

It would, of course, be quite wrong to think that this anti-modernist, 'antipodean
aesthetic', as it were, was of merely topographic, or geographic, interest. As
Kenneth Clark put it, 'in Australian landscape painting, as in all great landscape
painting, the scenery is not painted for its own sake, but as the background of a
legend and a reflection of human values.' In one sense, this quest of 'A Higher
Landscape' which could convey symbolic values was, as I have already suggested,
profoundly conservative—or at least conservationist. But it was also deeply radical.
For, as we shall see, the values which the Australian artists sought to express
through the metaphors of the intractable and alien terrain which confronted them
had never previously been successfully realised through painting. And they were of
profound relevance even to those who knew nothing of Australia.

I would go further than that. I believe that the Australian achievement in painting
would have been greater still if, during the 1960s and 1970s, Australian artists had
not been so greviously deflected by their desire to keep up at all costs with 'the inter-
national Jones's of the art of the moment'. The exhibitions that have been coming
out of Australia in the 1980s and visiting London, Paris, New York and Edinburgh
have been, in Bernard Smith's sense, infinitely more 'provincial' than that great
1961 show.

We have heard a lot about 'internationalism'—or evading the national issue—
recently. Stuart Morgan has even told us that in I think it was ten years time every
show in every gallery would be thoroughly 'international'. Actually, this much-
vaunted 'internationalism' of the fashionable modern art world, though hardly

'conservative' (let alone conservationist) is deeply reactionary. It is really no different from the corporate 'internationalism' of MacDonald's, Playboy, or the Hilton Hotel. And it meets exactly the same all-American tastes whether or not the Biennale is held in Rio de Janeiro, Timbuctoo, or Alice Springs. Oh yes, I know ... These days a dash of local colour is virtually obligatory. Every self-respecting Australian 'post-Modernist' uses a Vegemite rather than an Oxo, let alone a Coca-Cola ad! But then I expect there's an Eskimo Bar in the Alaska Sheraton, and a Red Indian Lounge in the White Plains Hilton. Actually to call this 'provincialism', as Bernard does, is to give the provincial vision a bad name. And I'm not at all sure that I want to do that. I really do prefer a parochial Constable sketch or a Nolan painting to an advertisement for Time magazine, or Marlborough cigarettes. So I'm not going to call this Art-and-Text Unsworth-Sydney-Biennale-British-Art-Show-Gilbert-and-George-Mike-Parr-Eureka-Woodrow stuff 'provincial' anymore. Rather I'll refer to it as Biennale-International-Club-Class-Art, or BICCA, for short.

The argument I'm putting before you is not just an argument about the corruption of Australian art. (Although it is certainly that.) What I have to say applies as much, if not more, to contemporary British art. If that Australian art show of 1961 had had the sort of effects I wish it had had on British cultural life then the British art show in Perth—especially the sculpture section of it—would have been rather different. For I wish that that 1961 Australian landscape exhibition had encouraged the best British artists to refuse that pseudo-international, BICCA, anti-culture, which, during the 1960s, began at first to obsess, and later to consume, them. And to show you just how bad things became for us British, I now want to turn your attention to another exhibition at the Whitechapel Gallery: this time to one held rather more recently—in 1983, to be exact. It was pure BICCA from beginning to end. And yet it was the reason, indeed the only reason, why Malcolm Morley won 'The Turner Prize'. As a matter of fact, one of the few pleasant surprises of the British Art show in Perth was that Morley was left out. All the runners-up (bar one) were included: namely Richard Deacon, Gilbert and George, and Richard Long.

Some of you may already have heard of this 'Turner Prize'. (Readers of *Art Monthly* certainly will have done so.) But for those who have not, this was an award of £10,000 given for the first time last year to the person who, in the opinion of the jury, had 'made the greatest contribution to art in Britain in the previous twelve months'. Extraordinary fanfares of television publicity accompanied the award of the prize.

Now let me tell you something about this Morley and all he has done for art in my native country! As a young man, he spent some time in prison where he took a correspondence course in painting. Upon his release, he acquired a more orthodox education in art at the Royal College, and then promptly left Britain for New York where he has lived continuously for more than quarter of a century.

When biting into the big apple, Morley, predictably, made no attempt to preserve even a trace of the taste of those British cultural traditions he had barely known. On the contrary, he quickly established himself as a pioneer of 'photo-realism'. For

those of you too young to remember, this was a passing fad of the American 'avant-garde' which involved the transcription of photographic and advertising material into paint and canvas. Morley would mark up his chosen travel brochure image, or whatever, and a blank canvas of the same proportions, but a much larger size, with a grid. Then he copied what he saw onto the canvas, square by square. He took care to turn the source material upside down before transcribing it so that the subject matter would not influence him. The prison correspondence course must have come in handy for this painting-by-numbers technique.

Great claims were made for these fatuous images! For example, American critics loved to point out how they related back to, say Roy Lichtenstein's enlargements of comic strips, or Andy Warhol's screen-printed images. But by the end of the 1960s, Morley and his admirers found they had a problem. In BICCA circles, this sort of mechanical reproduction of mass media imagery was beginning to pass out of fashion. Predictably, one critic was soon to jump up and argue that—unlike Lichtenstein's, or Warhol's—Morley's intentions were, I quote, 'post-industrial'. The reason apparently was that Morley, I quote again, 'always surrounded the image with a smooth white field so that the real focus of the painting was not in the banality of the subject (as in Pop Art) but in the tension between illusionism and the flatness of the picture plane.'

Morley himself quickly took conspicuous steps to make his change of direction clearer still to the BICCA establishment. Instead of working from 'given' photographic material, he started to make use of his own hopelessly inept water-colours of his masturbatory fantasies. (Again, one can only assume his prison experience came in handy!) These he 'pointed-up' into huge canvases exactly as he had done before.

These new-style paintings are coarse, lacking in any sense of a tradition of painting, let alone a specifically British tradition. They manifest no hint of painterly nuance, or sensitivity, nor any trace of a perceptual—let alone an affective, or emotional—response to things seen in the world. How could it be otherwise given the way Morley lays his paint down? Morley himself attributes his change of direction to something he describes as CO_2 Treatment which, apparently, he receives for his continuing psychological difficulties from a dubious New York medical practitioner. Forgive my cynicism, but it also seems pertinent to point out that the new style quickly got our ageing con-artist acclaimed once again as a 'pioneer'—this time of the New Expressionism, or Bad Painting, which was rapidly squelching its way onto the centre stage in the wonderful world of BICCA.

As one critic outside the BICCA cartel so vividly put it: 'Malcolm Morley is a hopeless artist and a pathetic individual, who has spent the last quarter of a century living on the other side of the Atlantic. He has made no contribution whatever to national cultural life: he is not capable of doing so even if he wanted to. In Britain, his name is known only to a handful of art-world trendies, Charles Saatchi, and a few Whitechapel tramps.' Actually, you've probably guessed. I wrote that ...

Charles Saatchi, for those of you who don't know, is an international advertising man. He was behind Mrs Thatcher's successful, 'Labour Isn't Working' election

campaign, and the rather less effective Walter 'Fritz' Mondale for President jamboree. Saatchi, predictably, finds BICCA greatly to his non-existent taste. His private museum of BICCA junk art, recently opened in St John's Wood, contains no less than fourteen enormous Morleys. And God (and Charles) only knows how many Schnabel's, Salle's, Deacon's and Woodrow's.

Morley is also favoured by the faceless young fogies who, by their own confession, conspire together to decide who will be this year's BICCA internationally approved, art express, fashion-leaders. These international art bureaucrats are now much more important than commercial dealers: and unlike commercial dealers, they are not even answerable to the chastening effects of market forces. These fellows jet around the world from Biennale to Art Kunst promoting the odious tastes of BICCA. And in between flights, they sit on the panels which decide such things as the winner of the Turner Prize, for the greatest contribution to art in Britain in the previous twelve months. You have your equivalents here too: they are mostly British or American curators or media-space administrators who couldn't quite make it in the BICCA big-time back home.

Now it so happens that while I was working on a story exposing all this for the avid readers of *Art Monthly*, I met the wretched Mr Morley, by chance, in a Cork Street coffee bar. He was on a brief visit to England for the purposes of picking up his cheque. (He hadn't been able to attend the reception for the prize himself.) Somewhat ruefully, he revealed that there had indeed been moments in his life when he had done that at which one might have expected any winner of 'The Turner Prize' to have been exemplary: namely, looking at nature, and responding to it with aesthetic and imaginative interest. He directed me to a nearby commercial gallery and there, indeed, was a small Morley water-colour of a lake-district scene showing blue-sky, a mountain, and an expanse of water. Oh yes, it was a clumsy and heavy-handed sort of thing. Nothing to write home or even to *Art Monthly* about—though that didn't stop me doing so, nonetheless. It might, just possibly, have won Morley some sort of special mention in, say, Hackney Borough Council's Annual Amateur Art Exhibition. But I doubt it. It wasn't *that* good.

Nonetheless, in this little water-colour, there was some sense of light, life, and the lived experience of landscape. There was even a hint or two of sensibility, a trace of tradition, a flicker of painterly competence. I don't want to exaggerate the merits of the work: but it did indicate to me that if, after he had been released from gaol, Morley had not rushed off into BICCA's jungle of plastic values . . . if, perhaps, he had stayed at home, and looked into himself (without the help of CO_2) and out onto the English landscape (without straining his vision through the filters of travel agents' brochures) then, just possibly, he might have become—though never a Crome, Cotman, or Cox, let alone a Constable, and least of all a Turner—at least, perhaps, a worthy journeyman painter in an honourable tradition. But he didn't of course. No, he didn't.

Now you have your Morley equivalents over here too. Some of you may remember that last time I was here in Perth to deliver the first Jill Bradshaw

Memorial Lecture, 'Art in 1984', I compared Juan Davila's mixture of perversion, admass, and BICCA pretension to the material pumped out by Pornosec in George Orwell's novel *1984*. I also pointed out that, typically, Davila has complained that in Sydney Nolan's great pictures, 'the void of the land is forced to signify, ignoring the suture that it offers.' Nolan it seems should not have played about with landscape but should have turned his attention to the delights of imported American sex magazines, television programmes, and art fads as Davila himself has done. Naturally—if that's an appropriate word in this connection—Davila is included in almost every 'international' BICCA art fair and touring exhibition of Australian painting.

All this, if you think about it too much, is guaranteed to produce a state bordering on despair. And yet there *are* grounds for hope. One of them is the cynicism and indifference which BICCA art induces in those who have to deal with it. For example, I spoke to Alan Bowness, Director of the Tate Gallery, and Chairman of the jury which awarded Malcolm Morley the Turner Prize. He declined to say whether he personally thought Morley's work was of any aesthetic merit at all, and accused me of failing to understand that the Turner Prize was not about art at all. It was, apparently, rather a publicity gimmick designed to get media attention for recent art. So what did I expect? It rapidly became apparent that Alan Bowness no more believed in the art of the winner of 'The Turner Prize' than the creators, or consumers, of Coca-Cola advertisements actually believe that their chosen fizzy drink will bring about universal peace on earth. Or, come to that, than Charles Saatchi believes that Labour isn't working, or 'Fritz' Mondale was the unacknowledged redeemer of mankind ... or, indeed, than Tony Bond believes in all the art in 'The British Show'. BICCA art is the vapid and cynical product of the vapid and cynical values of vapid and cynical people: only the very silly, or the utterly 'provincial' (in Bernard Smith's most negative sense of that word) are really taken in by it.

There are also more positive grounds for hope. Back in 1974, John Berger, a British critic, argued that there was once a time when, in all art which was based on a close observation of nature, a whole cultural process had been involved. The artist, he argued, observed nature, and his work had a place in the culture of its time: that culture 'mediated between man and nature'. But Berger continued, 'in post- industrial societies this no longer happens'. The culture of post-industrial societies, Berger maintained, 'runs parallel to nature and is completely insulated from it.' Anything which enters that culture, he said, has first to sever its connections with nature. Even natural sights, or views, have been reduced in consumption to commodities. 'The sense of continuity,' he concluded, 'once supplied by nature is now supplied by the means of communication and exchange-publicity, TV, newspapers, records, shop-windows, auto-routes, package holidays, currencies, etc.' Everything, in fact, which I call in my jargon 'the mega-visual tradition'. All this, Berger argued, formed a 'mindless stream in which any material could be transmitted and made homogenous, including art.'

We can, I think, all recognise the scenario. But I believe Berger was being too pessimistic. At least, ten years after he wrote these words, there are many signs of

attempts to rupture with this mega-visual tradition, and to break with its whole credo of increased production, and inevitable 'triumph' over nature. Some artists, at least, are no longer prepared to accept the dissolution of all ethical and aesthetic values. Here and there we can begin to see signs of attempts to recover, recuperate, and where necessary, to recreate ways of seeing, responding to, representing, enjoying, transforming, and even abstracting from, the natural world which owe nothing to the outpourings of that mindless, anaethitising stream. Here and there, one might say, are scattered but spreading points of creative *refusal* of the mega-visual tradition, and its analog in Fine Art—the plastic world of BICCA.

Oh yes, these points are small and dispersed enough, especially when compared with that hideous, homogenised, 'mindless stream'. Often they are awkward, confused, and in themselves, unconvincing so they can easily be over-looked as insignificant. But I feel that there are more of them every day. Let me give you just two examples from Britain: one is an exhibition I saw at the Serpentine Gallery last autumn called, 'Landscape, Memory and Desire'. This was an attempt to revive a Higher Landscape, a landscape which, in Kenneth Clark's phrase, was 'a reflection of human values' by painters all of whom had been in one way or another, involved with some of the emptier reductions of Late Modernism. This exhibition contained work by one artist, at least, who seemed to me to have a touch of genius about her: I am referring to a young painter of whom I believe you will be hearing more in the future: Therese Oulton.

More generally, too, I would point to the formation of a group like Common Ground, which has been set up with the specific intention of forging 'new links between the practice and enjoyment of the arts and the conservation of landscape and nature.' I am sure that parallel events are taking place here in Australia if you start to look for them. Now these are small matters: but they are not insignificant. I would say that in various ways the argument is beginning to be heard, and seen, for a genuine 'post-industrial' aesthetic, for a complete rupture—a *diastis* certain theologians might call it—with some of the most tenacious of the underlying assumptions of Modernism. I am of course talking about something which goes far, far deeper than the putting of white borders round the edge of painted copies of picture post-cards, or providing a so-called critique of the mass media by reproducing its banalities and excesses in an even more extreme form—or breaking up fridges and car doors, come to that. For what is involved is a recognition that technology and mechanism, however we treat them and whatever they may be able to give to mankind, cannot provide us with the substitute for either an aesthetic or an ethic.

Of course the brave new world that is being created by the second industrial revolution through computers, micro-chips, and the new electronics, is here to stay. But gradually, I think, it is beginning to dawn upon radical and creative minds today that the role of the arts is not necessarily to assimilate themselves to these phenomena, to imitate them, nor to reproduce their anaethitisation of values. Rather, the task of the Fine Artist may be to affirm an alternative to all this: to ensure as it were that the new technologies are kept in their place—and that the space is held open within which the aesthetic dimension of human life can continue to flourish.

It is sometimes suggested that, in arguing like this, I am proposing a reactionary, or even a Luddite position for the Fine Artist. Rather, I am suggesting that the artist finds himself lined up with all those who today are questioning the notion of ever-increasing production, as the initiator of utopia on earth, and are attempting to challenge the way in which both human labour, and human aesthetic responses, are being collapsed by modern means of production into what Berger designated as that mindless (and I would add *heartless*) stream.

Fine Artists who are questioning Modernism at this profound level find themselves on the same side as the ecologists, conservationists, and all those who in recent years have shifted the argument away from discussion of the quantity of production—its economic aspect—towards the quality of the work men and women do, of the things they make, and of the environment within which they live and labour. Such artists align themselves with those who are concerned about the way in which technology and production have developed in an ethical and aesthetic vacuum, which is leading men and women to poison, pollute and potentially, perhaps, to destroy the planet they inhabit. Artists thus begin to engage again in that most fundamental of all debates: the rethinking and reworking of man's whole relationship to nature.

But what is the Fine Artist's specific contribution to all this? In the introduction to a book called *Second Nature*, published by Common Ground, Richard Mabey wrote that we have all become well-informed about the world's ecological crises, about the destruction of the tropical rain forests, the pollution of the oceans, the profligacy of agribusiness, and even about the economic connections between all of these. Yet he went on to say, this knowledge has remained curiously remote, not connected in any obvious way with our ordinary everyday experience. Mabey argued that the fate of the natural world—which is in fact also, of course, our fate—has been declared the province of specialists. He spoke of the need, in a very literal sense, to *bring the argument back home* to the local landscapes that are most people's experience of nature, and to the variety of personal meanings which they hold for us. This, I would suggest, may be among the most radical of the tasks facing the Fine Artist today.

I do not want to imply that this 'return to nature' is a simple matter: there is no greater challenge. And I want now to look briefly at the way in which an individual's position in time and place mediates that challenge. Some of you will already know how again and again in my thinking and writing I return to that moment when a 'Higher Landscape' arose in Britain in the later 18th century and reached its apotheosis in the era of Constable and Turner, before it became metamorphosed through the prism of Pre-Raphaelitism. In the second half of the 19th century this 'Higher Landscape' begins to disappear from view: it becomes transmuted into topography, or later into subjective abstraction. Meanwhile, the central, emerging, European Modernist tradition starts to look elsewhere for its values pursuing either the gods of mechanism, archaic symbolism, or expressionistic subjectivity.

When trying to explain this process, I have made much of a particular quotation

from John Ruskin. 'The British School of landscape, culminating in Turner,' he once wrote, 'is in reality nothing else than a healthy attempt to fill the void which destruction of Gothic architecture has left.' You can see the literal truth of this if you trace the obsession with the great cathedrals and churches in the paintings of Cotman, Cox, and Turner himself. Beyond that, however, Ruskin was pointing to the fact that this 'Higher Landscape' was only possible because those who engaged in it believed that nature was the literal handiwork of God; that there was a divine revelation to be found in the morphology of natural form if only one looked hard enough. This applied even to a 'naturalist' like Constable. As Kenneth Clark put it, in Constable's greatest work, naturalism is raised to a higher mode by his belief that since nature was the clearest revelation of God's will, the painting of landscape, conceived in a spirit of humble truth, could be a means of 'conveying moral ideas.'

But this whole aesthetic depended, for one thing, on living in a physical world which could be represented, if not as a Garden of Eden, then at least as something made by God for man, somewhere where men and women could live in harmony and recipricocity with a nurturing nature. England, of course, with its temperate climate, amenable to human life, and its richly fertile agricultural lands, regular, moderate and cyclical seasons, and its abundant evidences of divine presence in the landscape—there are, for example, more than 500 medieval churches in the country of Suffolk alone—actively invited such a response. But this 'Higher Landscape' aesthetic also depended upon *belief*: the belief that nature really was the literal handiwork of God. In the 19th century, the rapid development of the geological sciences at first threatened and finally shattered precisely that belief: with the waning of natural theology, the days of 'The Higher Landscape' were numbered.

Many artists fought against the collapse of this system of aesthetic and spiritual perception as long as they could. One of the commonest ways of doing so was to leave England and to make a trip to the Holy Land in the belief that there, at least, one might still find rocks and stones which bore witness to the incarnation of God within them, instead of being just dull matter. As some of you may have heard me explain before, Holman Hunt went to Palestine when his vision of England as God's orchard was beginning to fail him. He went deliberately to find 'types', or natural images, which proclaimed the incarnation of God within the material world. Instead, he found a mangy goat, which dropped dead on him, and a wasteland, a frightening desert. On the shores of the Dead Sea, he wrote, 'It is black, full of asphalte scum—and in the hand slimy, and smarting as a sting—no one can stand and say it is not accursed of God.' And of course if God had abandoned the Holy Land itself, then the Sea of Faith had withdrawn forever. Nothing seemed to be left except the salty and naked shingles of the world. 'Are God and Nature then at strife,/That nature lends such evil dreams?' asked Tennyson. And nature became for him not a garden but a wilderness of 'scarped cliff and quarried stone' from which all 'types' and traces of divine presence had irrevocably disappeared. He evoked the image of a burning desert of inhospitable sand. This spreading loss of belief in God's immanence within nature led to ominous and despairing pictures like

William Dyce's great painting, *Pegwell Bay*, of men and women lost on the beach, searching for fossils, in front of lowering cliffs with a comet overhead; and also to the progressive intrusion of the appearances of the real into all landscape painting. Landscape, against itself, became nothing more than the depiction of the intractable appearances of things in the external world. It was but a small step from such depiction of appearance to the re-presentation of real or actual elements of the natural world as art. The last decadent and mannerist moment of this tradition can be seen in 'The British Art Show' at the Art Gallery of Western Australia, here in Perth today in Richard Long's circle of gathered stones.

And with the advance of industrialism, it seemed that the fate of 'The Higher Landscape' was signed, sealed and delivered. Ruskin professed a very common sentiment when he declared that if a single point of the chimney of the Barrow iron-works showed itself over the green ridge of the hill in the lower reaches of his beloved Coniston water, where he had bought a house, 'I should,' as he put it, 'never care to look at it more.' Industrialism meant that even if you held on to your religious beliefs, the physical landscape itself had been so violently changed that the old aesthetic was no longer possible. There seemed no escape from 'naked shingles', 'asphalte scum', 'scarped cliff and quarried stone', or desert sands.

Or almost no escape. There were those who tried against the tides of secularism and advancing industrialisation to refuse modernism and to maintain, at least, an image of man in harmony with himself and nature through evoking the residual, consolatory power of the British landscape. Nor was this vision by any means confined to the politically conservative. Characteristically, William Morris, who was a revolutionary socialist, could nonetheless write of the English countryside: 'When we can get beyond that smoky world, there, out in the country, we may still see the works of our fathers yet alive amidst the very nature they were wrought into, and of which they were so completely a part. For there indeed if anywhere, in the days when people cared about such things, was there a full sympathy between the works of man and the land they were made for.' Morris went on to say that the land was a little land, 'too much shut up within the narrow seas, as it seems, to have much space for swelling into hugeness; there are no great wastes overwhelming in their dreariness, no great solitudes of forests, no terrible un-trodden mountain-walls.' All, he said, is measured, mingled, varied, gliding easily one thing into another: 'little rivers, little plains, swelling, speedily-changing uplands, all beset with handsome, orderly trees; little hills, little mountains, netted over with the walls of sheep-walks; all is little; yet not foolish and blank, but serious rather' and, as he put it, 'abundant of meaning for such as choose to seek it: it is neither prison nor palace, but a decent home.'

Now this sort of neo-pastoral, British thinking is much criticised by both the left and right wing flanks of the Modernist tradition, whose arguments, as so often happens, are remarkably similar. We know what the left has to say about this: its arguments are so frequently rehearsed in the art world. But in his recent book, *English Culture and the Decline of the Industrial Spirit*, Martin J. Wiener, an American, and no Socialist, argued at length that it was the effect of the rustic and

nostalgic myth of an 'English way of life' which had transferred interests and energies away from the real purpose of life: the creation of material wealth, and the escalation of the productive process. The rustic myth was the source of Britain's decadence as a great industrial power. Intellectuals, as it were, preferred to poke around those medieval Suffolk churches, and to take pleasure in conserving local landscapes, when they should have been working for IBM or General Motors.

Against both the modernist left and the modernist right, I would defend the role of this myth in our cultural life. Its effects can be seen in all sorts of positive and creative ways: its absence leads to BICCA. One of our best novelists in Britain today is the feminist writer, Fay Weldon. She recently published a letter to an (I presume) imaginary relative, Laura, who lived in Sydney and was thinking about coming back to live in the English countryside. Did Fay Weldon think that was a good idea? I'll tell you what Fay Weldon had to say about Australia in a minute: but what she wrote about the power of the English countryside, and its continuing strength, echoed William Morris's words in every particular. Here, she said—writing, of course, from England—in the shadowy North, nature long ago settled into sedate ways, and incorporated human beings into its scheme of things. 'We are, here in England,' she wrote, 'part of the landscape. We have to be. Every acre of this densely populated land of ours has been observed, considered, valued, reckoned, pondered over, owned, bought, sold, hedged—and there's a dead man buried under every hedge, you know. He died of starvation, and his children too, because the common land was enclosed, hedged, taken from him. We owe the neat, patched, hedgerowed beauty of our countryside to unwilling human sacrifice: that I suspect is its power over us. We owe it to the past to appreciate its beauty. It's the least we can do. It's serious.'

The best achievements of British art, this century, have always involved a *refusal* of certain aspects of Modernism and a *conservation* of at least something of this kind of imaginative response to natural form—including, or at least incorporating, the human form. *Great* British art, in other words, has been powerfully inflected by this 'rural myth' which commentators on the provincial left and figures like Weiner, of the New Right, are both so eager to usher off the stage. I'm thinking here of the best paintings by Stanley Spencer, Graham Sutherland, John Piper, the Nashes . . . all of whom predictably owe more than something to the retention of elements of religious belief, in particular concerning divine immanence. But a similar sensibility was elaborated in a more thoroughly secular way by Henry Moore, the most out-standing British artist of our century, who conceived of landscape not so much as a consoling *hortus inclusus*, or walled garden, but rather as the nurturing body of a loving mother . . . And also, of course, by David Bomberg, who rejected modernist mechanism and the then prevalent 'international' aesthetic as early as 1918, and devoted himself to a search for 'the spirit in the mass', through drawing. Indeed, the only *serious* work in 'The British Art Show' at the Art Gallery of Western Aus-tralia—that is the painting of Auerbach, Kossoff (both incidentally pupils of Bom-

berg's) and Freud—is deeply indebted to that tradition. (John Walker, Ken Kiff, and Le Brun are, perhaps, semi-serious.)

I am not a great believer in the necessity of 'deconstruction' in aesthetic life: I not only respect the creative potency of the British pastoral vision; I also believe its effects on our cultural life have been wholly beneficial. The only problem has been that they have not been sufficiently extensive or pervasive. Only parts of Hampstead, and various forgotten suburbs, and *not* the whole of London, became the 'Garden City' of which William Morris dreamed. Nonetheless, having said this, I am prepared to agree that there *is* something faintly quaint, even suspect, about this British rural utopian myth, and its effects, in and out of art. And this was brought vividly home to me when, in that open letter to her Sydney relative, I read what Fay Weldon had to say about *Australian* landscape.

'Living in Australia,' Fay Weldon writes, 'where they don't, come to think of it, have countryside, merely outback; the interior being altogether too large, too hot, too unregarded, too unobserved and in general too alarming to be described as anywhere but somewhere else: namely *out the back*—is,' she says, 'dangerous but hardly serious. Snakes, spiders, sharks, bush fires, rip tides—all out to kill and if they don't get you, skin cancer will. But these concern survival in the outer world, not, as does the English countryside, survival of the soul itself. Australia, in this as in all, is O levels, England is A levels.'

I am not, I would hasten to add, quoting this in order to endorse it! This is surely the English provincial vision at its most blinkered, its least insightful. But Fay Weldon goes on to justify her position by arguing that nature in Australia is something external—humans live perched on the surface of an unfriendly, uncomfortable, wildly beautiful land: its flora, she claims, is stark and ravishing, its fauna raucous and bizarre. 'South of the Wallacean line, in the hard bright sun, nature experiments; who can take an emu seriously?'

But Fay Weldon is on to a truth she seems almost not to notice: and, in the end, I think that someone who writes in this tone about Australian landscape just has not taken her experience of *British* landscape seriously enough. It is as if Fay Weldon just wants to forget altogether the terrifying revelation of the mid-19th century that nature was not an English garden made by God for man, but an inhospitable desert in which each individual had to struggle tenaciously and destructively for life. After I had lectured here in Perth a year ago on precisely this 19th century experience of nature, I went on a field trip with Don Bradshaw of the Zoology Department at the University of Western Australia. We drove up through the Pilbara to the North West. At one point on the journey, we both glanced out of the vehicle's window together. A mangy looking sheep was trying to drink from a trickle of water. A skull lay nearby . . . The red, red sands stretched far away. Don said, 'The Scapegoat'. It was exactly what I was thinking.

Ruskin himself found that Turner's vision of the world as the handiwork of God finally failed him: indeed, he became obsessed with the idea that nature itself was failing. 'That harmony is now broken,' he wrote, 'and broken the world around:

fragments still exist, and hours of what is past still return, but month by month the darkness gains upon the day, and the ashes of the Antipodes glare through the night.' He was, of course, speaking of the *English* night: it is a compelling image. And now, perhaps, is the moment to point out that in her little discourse about the *seriousness* of English landscape, Fay Weldon forgot to mention that those elements which gave it such seriousness are fast disappearing. About 80 per cent of the medieval hedgerows about which she wrote so vividly have been chopped down in the last quarter of a century; the medieval woodlands have all but disappeared; acid rain and acid dust are corroding and destroying the old Gothic buildings. And the Nature Conservancy Council recently reported that even Suffolk, that essentially English terrain, beloved by so many of our greatest landscape painters, is in danger of being returned to a prairie within a decade by agribusiness. The trim and mani- cured English landscape which provided the basis for the rural myth is itself dis- appearing. The glaring prairie which is emerging in East Anglia is peppered with cruise missiles, and military bases, which threaten to reduce the entire globe to the dust of the antipodes. England, it might be said, is fast becoming a landscape of which we can no longer feel a part, perhaps not even in those 'moments' of which Ruskin spoke. It is ceasing to be a 'decent home'.

Indeed, it is no accident that the best work by all those artists to whom I pointed, as making use of the English rural myth, was made in war-time. They responded to a charred, wounded, and injured landscape which they struggled to redeem, at least imaginatively, through that older aesthetic of 'The Higher Landscape'. This was true of Spencer, Nash, Piper, Sutherland, Moore, even Bomberg himself. Nor need we be surprised that after the war, Stanley Spencer turned to such themes as *Christ in the Wilderness*, of which you have such vivid examples, appropriately, here in Perth, on the edge of the great Western desert. Of course, artists like Drysdale, Tucker, and other pioneers of Australian landscape painting, borrowed heavily from Moore and Sutherland as they too struggled to find the aesthetic and pictorial conventions which would enable them to wreak that vision of secular redemption even upon the glaring antipodean desert itself. Fred Williams, as I have argued else- where, pre-eminently succeeded: through pictorial illusion he transformed even the hallucinating wasteland of the Pilbara into an image of consolation and aesthetic reconciliation. There is no higher task which the Fine Artist can attempt today.

Fay Weldon should have known better. After all, she's old enough to remember that great 1961 Australian landscape show. At a time when a desert of ashes threatens to engulf us all, and there is, indeed, a real danger of bringing about a failure of nature, through our own actions, Australian landscape is very serious in- deed—way beyond A levels! But the point may not be to decide between these visions of a country garden and a desert, but rather to say that, at this time, the world needs both: or, to be more exact, it needs the image of the desert which is saved, and transformed, initially through the imaginative aesthetic process, into a garden once again. Both the English and the Australian imaginations, springing out of their respective geographical landscapes and cultural traditions—and indeed out

of the sometimes prickly and abrasive inter-action between the two—have something specific and irreplaceable to contribute to that process. And this is something BICCA and its bureaucrats have never understood. We can be at our most universal when we are at our most provincial, even parochial—or least 'international'—so long, that is, as we are prepared to respect the provincialism of others, as well as our own.

Towards a Fuller Meaning of Art

PETER FULLER INTERVIEWED BY COLIN SYMES

COLIN SYMES:

You have associated yourself with the Marxist tradition. Yet you have consistently dissociated yourself from the Althusserian variety of Marxism, so dominant in post-war writing about society and art. In fact you see Louis Althusser as a sort of Stalin in residence at the Ecole Normale Superieure, diminishing, as he does, the importance and sovereignity of the human agent. If you have a doyen among post-war Marxists, it is the Italian, Sebastiano Timpanaro, who challenges the ideology-is-everything thesis of Althusser. There is also a strong streak of Utopian socialism, of the sort embraced by William Morris, in your writings about art. You have said that 1968 was an *annus mirabilis*, providing a glimpse of an 'alternative political and social future'. As a Marxist, you look forward to a better society, one based on socialist principles; but what would Fuller's socialist society actually be like, and what role would the arts play within it?

PETER FULLER:

As far as 1968 is concerned: I was at university at that time. The colleges were in ferment everywhere. There were mass demonstrations against the war in Vietnam, and a great welling up of interest in all the 'events' that were taking place in France. Marxist literature became widely available in university bookshops and an underground or 'alternative' press sprang into life. After I came down from Cambridge, in the summer of 1968, I worked for a local newspaper in the City of London called *City Press*; its motto was, 'The Voice of Honest Capitalism'! I also wrote a 'City Dwarf' column for *Black Dwarf*—one of the 'revolutionary' fortnightlies. Now evidently in those days many of us believed that capitalism was on the verge of collapse and that imminent historical changes *for the better* were about to take place. There was tremendous optimism, enthusiasm and hope. Many students would have echoed Wordsworth's youthful thoughts about the French Revolution, 'Bliss was it in that dawn to be alive, But to be young was very heaven!'

The rise of Althusserian Marxism was a reaction to the failure of that 'moment' of 1968. Marxism went off the streets and back into the institutions where it became a

45

theology without God or man, a hermetic, academic discipline with an erudite monastic literature. I did not find very much to interest me in the mainstream of post-1968 Western Marxism; I was—and I still am—repelled by the disappearing act which the Althusserians practised on the human subject. I thought that a theory which disposed of all individuality, freewill, moral choice, even, it seemed, the human body itself, was worthless or rather, dangerous. As far as art and aesthetics were concerned, Althusserianism contributed nothing: absolutely nothing. I think you can see its ill-effects in, say, the way art history has been pursued within the Power Institute in Sydney.

I broke completely with this tendency in a paper called, 'In Defence of Art',[1] which I delivered at a conference on 'Art, Politics and Ideology' in 1979. At the time, this paper infuriated the post-structuralist brigade. But I cannot say this bothered me. I'm not really even interested in debating with these people anymore. E. P. Thompson said all there is to say about them in his book, *The Poverty of Theory*.[2] Thompson, as you know, also wrote a gripping biography of William Morris;[3] these works had a much greater influence on me than anything Althusser ever wrote.

But I don't want to be misunderstood. I'm not trying to argue that the Althusserians, Structuralists, Post-Structuralists, and what-have-you, betrayed the 'true' spirit of 1968. Least of all do I wish to revive that spirit! I am arguing for something more radical than that. I agree with Raymond Williams when he says that we must begin to rethink the whole socialist enterprise, from its roots upwards.

I think that some of us are beginning to understand more and more about the way in which the *economic* emphases of the historic labour movement simply mirrored some of the most destructive aspects of capitalist development. The idea that utopia on earth would come about through increased *productivity*—through a hardening triumph over nature—was common to the panaceas offered by left and right alike. Today, however, it may be more important to question fundamental assumptions of this kind than to choose between the existing left or right programmes.

When I look back on my own experience of 1968, I find I am not giving much thought to the 'revolutionary' ideas of that era. So many of them sound like nothing more than dead rhetoric today! Rather, I find myself thinking much more about the practical, decorative work of William Morris, who refurbished the Great Hall in Peterhouse, Cambridge, where I ate every night as a student. I am interested, too, in the whole tradition of conservative opposition to free-market and economic competition—in Cobbett, Carlyle, and especially, of course, John Ruskin. Peterhouse has long fostered an interest in this kind of thinking. Someone once complained after a lecture I gave at the Ruskin School of Drawing in Oxford that I was trying to wed Marxism to Peterhouse 'Higher Toryism'. It was meant as an insult . . . but I thought it fair enough.

Of course, I remain a socialist. My whole formation has been profoundly and indelibly inflected by the Marxist tradition. But fidelity to the shibboleths of socialism is of much less importance to me than the pursuit—in theory and practice—of those

forms of social life in which the majority of men and women can live freely, happily and creatively. Evidently, I don't think corporate capitalism, even in its new monetarist variant, has much to contribute to that quest. But nor do I think those forms of socialism realised in the East, or advocated by any of the different sectors of the labour movement in the West, are very relevant either.

I believe that those areas of human life which can be substantially ameliorated by political change are more limited than many socialists have traditionally assumed. If there is, as you say, a strong streak of Utopianism in my writings about art, there is also an even stronger streak of materialist pessimism! But among those things which undoubtedly could be improved through political change are the quality of the work people do, and of the physical environment they inhabit. These things are directly affected by the nature of the productive system. Now the extension of democracy and of economic justice are all very well: but if they are accompanied by the destruction of the aesthetic element in labour, the elimination of art, and the poisoning of both the natural and human environment, then it is at best doubtful whether they are really the changes that matter. I believe that the ethical and aesthetic dimensions of social life are every bit as important as the political and economic; nor, of course, would I accept that the former are merely derivatives of the latter. In this respect, I feel I owe much more to the tradition which derives from John Ruskin than to the traditional preoccupations of Marxism. Ruskin, incidentally, has had a far greater influence on me than William Morris.

COLIN SYMES:

What is your view of those cultural practices which are oppositional in character, which have as their hidden agenda the promotion of a socialist society? In your writings you quote approvingly Herbert Marcuse's view that 'the political potential of art lies only in its aesthetic dimension'. It is enough for art to be art for it to subvert the dominant consciousness. In other words, art does not have to be overtly political for it to achieve the 'transcendent goals of change'. You have taken issue with those who have advocated an art for society's sake. Indeed, an art which consciously dons political garments is a travesty of art. Would you care to comment?

PETER FULLER:

I think perhaps you are inadvertently misrepresenting my views a bit here! You should remember that the slogan, 'Art for Art's Sake', as used by the 19th century aesthetes, was itself 'oppositional in character'. Oscar Wilde—a critic for whom I have considerable respect—associated aestheticism not only with criminality, but also with the struggle for socialism. Now I certainly believe that the political dimension of art lies only in its own aesthetic dimension. I have tried to show how contemporary means of production—whether in socialist or capitalist ownership—tend to menace this vital aspect of human work and life. I have not therefore taken issue with those who have advocated an art for society's sake. I have rather taken the

more profound position that the social function of art can only be fulfilled if art puts truth to its own aesthetic dimension first. I never forget that William Morris, revolutionary socialist, was a pattern-maker and wallpaper designer. Indeed, I think he came to socialism because he—wrongly as it happened—believed that socialism would preserve and extend the 'joy in labour' which he discovered in his craft and artisanal activities. Morris's ideas about aesthetics and work interest me far more than the muddled political programmes through which he believed they might be implemented in the world.[4] It is one of the many paradoxes of this most paradoxical of men that, even today, his most politically significant work remains his 'Willow Bough' wallpapers, and his 'Honeysuckle' chintzes, rather than his very tired and conventional political tracts.

COLIN SYMES:

Much of your art criticism has been directed against the proferrings of the international avant-garde. Josef Beuys, Victor Burgin, Richard Hamilton, Anthony Caro . . . you see their 'pornography of despair' as you have called it, as part of the prevailing decadence in art. The way British artists (and Australians too, for that matter) have cultivated an obsequiousness to this tradition has led to an impoverishment of the aesthetic dimension. Yet there are artists, and you have written about them, who have barricaded themselves against the assaults of the avant-garde and have produced an art loyal to the 'genuine' traditions of art. Could you say something more about this oppositional tradition of art, and why it is you believe the international avant-garde represents such a false tradition?

PETER FULLER:

I will have to answer this question in a rather round-about way, which relates to what I have just been arguing. I think that we must begin to take seriously the arguments propounded first by John Ruskin, and later reiterated by Eric Gill:[5] namely that the most fundamental objections to capitalism are ethical, aesthetic, and ecological—not economic. It is perfectly possible to win the economic argument, in both theory and practice, and to discover that you have not changed anything like as much as you hoped!

Indeed, if you make the economic objection primary, as so many Marxists do, you immediately concede far too much of the argument. The belief that economics are all-determining may not be so much a fallacy of Marxism, as a distortion introduced into social life through the practical functioning of capitalism.

Of course, if the reward a man receives from his labour falls—for whatever reason—below a certain level, life will become intolerable for him. Such conditions are not to be endured. But it by no means follows that rectification of oppressive economic and political conditions of labour will necessarily render men and women happy, and eliminate the experience of alienation.

The traditional Marxist solution to the problem of labour has always been to advocate that the workers should rise up, secure control of the means of production,

and thereby receive the full share of the 'profit' from their toil. There are many objections to this scenario: not the least is that it is perfectly possible to imagine a situation 'under capitalism' in which a particular group of workers receive a lower-than-average share of the profits in the form of wages, but are happier than average in their livelihoods because they enjoy what they do, and the environment in which they do it, and further conceive of it as personally fulfilling and socially meaningful. Many craftsmen are, in fact, in this position today. I am not, of course, arguing that such individuals should be denied the just rewards for their labour. I am, however, insisting that if such individuals were transferred 'under socialism' to monotonous forms of factory or office work, involving shoddy goods and services, they might well feel that they preferred their pre-socialist situation—even though 'under socialism' they participated in the ownership and control of the means of production.

This is not just a nice argument. One of my main objections to socialism as it unravelled in the East, and as it is still advocated in the West, is that—with the exception of a few individuals like William Morris—socialists have rarely even considered these vital qualitative dimensions of work. Indeed, in the USSR, the State smashed traditional peasant cultures, and the aesthetic and productive life which went with them; introduced collectivisation, with ferocious brutality; and escalated industrialisation, according to the quintessentially bourgeois belief that a Five-Year Plan to increase productivity would necessarily make the world a better place—regardless of how that increased productivity was achieved. All this is commonly advocated as 'The Way Forward' in the West, too. I believe that it leads to a condition I have described as social 'General Anaethesia'—and although it makes some difference whether one endures a 'left' or 'right' version of this, the choice can hardly be regarded as significant.

My objection to the international avant-garde, as you call it, is that it simply mimics, or mirrors those forms of productive life which I regard as part of the problem, rather than as part of the solution. It celebrates the spread of anaesthesia!

This was, of course, especially true of the modern movement in architecture, which has had such a tragic and catastrophic effect on your Australian cities. Architectural Modernism served communist, Fascist, and corporate capitalist societies alike. There is little to be deduced from this except that, despite vociferous claims to the contrary, Modernism was not so much politically 'clean', or 'progressive', as politically promiscuous, as an aesthetic. It could be so precisely because all the political systems Modernism served—in Mussolini's Rome, or Rockefeller's New York—equally failed to celebrate 'joy in labour', or the creation of conditions which might facilitate enjoyable and meaningful work.

Take post-second world war American art. Tendencies like Pop Art and Photo-Realism simply mimicked the anaesthetic techniques of what I like to call 'The Mega-Visual Tradition'. Minimalism reproduced the modular anonymity of modern mechanical production. And conceptualism reproduced the aesthetically empty procedures and concerns of modern information processing. It really makes very little difference whether such art incorporates these techniques collusively or critically:

Hamilton is not significantly different from Burgin, or Juan Davila. Through renouncing the pursuit of the aesthetic dimension, all such artists end up as cultural collaborationists.

I think that a genuine, post-modernist aesthetic can only emerge when artists declare a *diastis*, or complete break, with the anaesthetic preoccupations of modern 'culture'. We need to evolve an aesthetic rooted in the imaginative response to nature, to the whole world of natural form. Despite the blinkered concerns of the ultra-modernists, and avant-gardists, etc., many artists have in fact attempted this in our century. Take the case of David Bomberg, in Britain: he was already a post-modernist by 1920! Bomberg advocated the pursuit of the spirit in the mass, through engagement with nature.

It is important to emphasise that most good art, this century, has been produced against the grain of Modernism: even when it has been produced within the Modernist tradition, it has often been its aesthetically conservative, rather than 'progressive' qualities which have made it great. Picasso, for example, was a dazzling draughtsman; Matisse and Gauguin were outstanding colourists with extraordinary mastery of decorative effects. Think, too, of the sculpture of Gaudier Brzeska, Jacob Epstein, and Henry Moore, of the painting of Graham Sutherland and John Piper in Britain, or that of Sydney Nolan, Arthur Boyd and Fred Williams in Australia. For all these artists, an imaginative response to nature was far more important than the celebration of mechanism or the adoption of a tendentious political position; indeed, most of them looked back rather harder than they looked forward. I don't think any of them was remotely interested in developing a critique of the mega-visual tradition ... or any of those things which artists like Hamilton and Burgin regard as so important. Rather, they all tried to affirm those aesthetic values which were being destroyed by modern 'culture'.

COLIN SYMES:

You have a somewhat jaundiced view of post-modernism. You seem to be saying that its practitioners who are, in the main, confessed anti-capitalists, have, unbeknown to themselves, created an art that is in cohorts with the imperatives of capital. The basis for this argument is that contemporary artists of the likes of Richard Hamilton and Victor Burgin have adopted the methods of the 'Mega-Visual tradition', and this has led to an obfuscation of the real roots of art in drawing and human expression. Would you care to comment?

PETER FULLER:

Haven't I answered this already? Let me be quite clear. Much of the art of the later 1960s, 1970s, and 1980s, which presented itself as being 'avant garde', progressive, political, 'left-wing', etc., in fact mirrored the techniques and anaesthesia of modern advertising and information technologies, while it renounced the *sine qua non* of good art—that which Marcuse described as 'The Aesthetic Dimension'.[6] In so doing, Late Modernist Art reproduced the deeper problem which I pointed to

earlier: the left itself—in areas quite other than the aesthetic—has tended to incorporate many of the most destructive aspects of capitalist development, especially its belief in the social efficacy of ever-increasing production, whatever the cost in ethical, aesthetic and ecological terms. Thus much tendentious leftist art is, I believe, collusive with the most negative aspects of modern capitalism.

This, at least, is the argument I would evince to explain the very negative response which the sort of artists you mention evoke in me. I believe that the whole idea of developing a critical stance towards the mass media, as a substitute for aesthetic affirmation, is a non-starter—even though it is vociferously advocated by many so-called 'artists', and critics like John A. Walker.[7] We already know that a system like modern advertising is capable of incorporating anything into itself: revolutionary slogans can be used to sell bras and beer; the longing for peace can be warped to induce a preference for one brand of soft drink over and above another . . . When an artist like Victor Burgin 'criticises' the mass media using its own techniques, he contributes to those media—and does so inconsequentially. The audience for a Burgin poster is, after all, negligible. And one has to add that even if his criticisms of the mass media were effective, they would have nothing to do with the creation of art, with the affirmation of that excluded aesthetic dimension. But really, aren't we talking about dead-ducks? Is anyone still stuck in this particular cul-de-sac today? This particular psuedo-fashion is surely finished.

A really radical artist, in the current British context, is Henry Moore. As you know, Henry Moore has pursued the arts of sculpture and drawing all his life. He has never shown any interest in the ideology of mass production, or mass reproduction, in new technologies, new media—or any of those things we assume to be emblematic of the modern world. Moore's subject matter has always been limited to traditional themes: the mother-and-child, the reclining woman, the fallen warrior, animals, kings and queens. But I would say that the radicalism of Moore's greatest sculpture lies in the fact that it affirms this aesthetic dimension—which is elsewhere disappearing.

Look at the marvellous drawings of sheep and lambs Moore has produced over the last fourteen years. These images, at once monumental and intimate, are redolent with all the tender authority which we might expect of the old age of genius: they have a quivering beauty which reminds me of the last drawings of Michelangelo . . . You never see anything like this on an advertising hoarding, or in the work of those who believe that it is their duty, as artists, to produce 'critiques' of such hoardings. But it is the very estrangement of Moore's imagery from stultifying anaesthesia—its rootedness in his imagination and tradition—which moves us, if we are at all capable of being moved.

COLIN SYMES:

A good deal of your writing is devoted to delineating 'a material basis for aesthetics'. You argue that most Marxists (including Marx himself) have avoided the question of how it is art 'outlives its times' and the socio-cultural context in which it

had its provenance. Art, you constantly vaunt, is shaped by, yet transforms, ideology. This is because art taps in to the 'relative constants of human behaviour', e.g. sexuality, grief, loneliness, euphoria . . . Will you say something about this, and how it is that this view of art might lead to a materially-based aesthetic?

PETER FULLER:

I hope that some of the things I have said about Henry Moore have already pointed in the direction of an answer to this question. You will remember that I went to a conference on 'Art, Politics and Ideology' in 1979? Well, there I fell into discussion with a prominent 'post-structuralist', Marxist-Feminist, art-historian. I remember I said to her, at one point, 'Well then Griselda, how do we know that the Laocoon is in pain?' To which she replied—and she was not joking—'We know the Laocoon is in pain because we have studied the modes of production prevailing in Greece at the time it was made, and the signifying practices to which it gave rise.' To which I replied, 'But Griselda, he's being strangled by a sea monster.' 'Yes,' she retorted, 'but we have no means of knowing whether or not he's enjoying it . . .'

It was as a result of exchanges like this that I realised that most Marxist art historians had an extraordinarily naive conception of what constitutes the material basis of aesthetic experience, and aesthetic work. Among those who influenced my thinking at this time was Sebastiano Timpanaro.[8] Timpanaro exposes the way in which so much recent Marxism—while claiming to be 'materialist'—ignores the biological and physical levels of human life, and exaggerates the determinative significance of economic and political factors. Timpanaro shows how Marxism has manifested a false triumphalism towards nature—just like 'progressive' capitalist thinking, and practice.

Although himself a Marxist, Timpanaro constantly draws attention to that which cannot be changed; he refers to an underlying human condition, which continues regardless of historical circumstances. (It can be altered, he argues, only by the slow processes of biological evolution.) He points out that since the beginning of civilisation, men and women have lived their lives in bodies which are very much as they are now. Though everything is mediated through historical circumstances, the range of human emotions has not altered much either. Now, as you know, Marx was quite unable to give a satisfactory explanation to the great conundrum of historical aesthetics: that is how great works of art can transcend their time and place and give pleasure in societies quite different from those in which they were created. Timpanaro, however, suggests that the relative constants of human experience—such as birth, sexuality, love, mourning at the loss of others, a sense of smallness given the limitlessness of the cosmos, and death itself—may have much to do with this. Thus we can be moved by the Laocoon, even if we know nothing of Greek mythology and social life, if only because it presents us with a vivid representation of the human body in struggle and in suffering.

But Timpanaro's persuasive argument has been further extended by Raymond Williams, who has talked about the biological elements in the material processes of

making art, as well as in the imagery. He has referred to the decisive importance of, say, the voice in singing, rhythm in poetry, and certain combinations of colours and shapes in painting. The significance of such components can be—and often is—of decisive and central importance in determining the quality of a work of art.

I think you can see the importance of both these levels in the work of Henry Moore: one reason why we can respond to his best works, and why men and women will always be able to respond to them, whatever social transformations may or may not take place, is that they are rooted in the imaginative and affective response to the mother's body.

Every one who is human is of woman born. But there is more to it than that. Despite advances in technology, the capacity and potentiality of the human hand in relation to stone, and other materials, has not changed greatly since Sumerian times: as long as there are human beings, it will always be possible for them to respond to the way in which Moore has worked the materials he has used, and rendered them expressive . . . Self-evidently, I believe that considerations such as these inevitably lead us away from the rabid idealisations of much recent Marxism towards the material basis of aesthetics.

COLIN SYMES:

Will you say something about the craft revival, a phenomenon which is just as evident in Australia as it is in the United Kingdom? You obviously see it as a healthy development in what is otherwise an aesthetically ailing society, which will only become healthier in the two-tier economy of the post-industrial society, where, as you see it, objects of primary necessity will be fashioned by machines, leaving men and women enough 'surplus consciousness' (and the phrase is Bahro's) to engage in aesthetic labour. Obviously, there is a lot of 'News from Nowhere' in this vision of a better possible world. Do you think we are close to Morris's Utopia, wherein all citizens will realise their full human potentialities in cultural activities of one sort or another?

PETER FULLER:

The craft revival in Britain has hitherto been a false and depressing phenomenon. It happened because a conservative Government decided to 'solve' the problem of the disappearance of the crafts by establishing a Crafts Council, which proceeded to create a sort of reservation, outside of ordinary economic life, for craft activity. No direction was given to those who entered the reservation as to what the work they should do might be like. Men and women were just paid for being 'Artist Crafts-Persons'. Predictably, much Craft Council sponsored work is neither beautiful nor functional: it tends to be ultra-modernist, 'experimental' rubbish—'unwearable' jewellery, tapestries which question the nature of tapestry-making, that sort of thing. In other words, as I have argued at length in my book, *Images of God*, the craft revival has simply repeated all the mistakes that were made in the practice and patronage of the Fine Arts after the second world war.

Please do not conclude from this that I am against the crafts! On the contrary, I would like to see a society in which automated, mass production developed *alongside* a genuine renaissance in the arts and crafts. I am not against technological development as such: I am against the way in which it has been allowed to usurp the place of creative and aesthetic work. I agree with William Morris when he said that you can get a machine to make anything—except a work of art. This was not an argument against machines so much as an affirmation of art, and craft. There are some things that machines can do very well for us: but they should be our tools and servants, not our masters. They should be used to free mankind from degrading and repetitive toil and drudgery in order that we can have more time, and cultural space, for 'joy in labour': at the moment, machines are simply eliminating that joy in labour—and that space for culture—altogether.

Yes, my ideas here do owe something to William Morris—just how much, you can judge from my Jill Bradshaw Memorial lecture: 'Art in 1984'.[9] But things have changed a lot since Morris's time. When he wrote, most industrial processes were labour-intensive: they seemed to imply that, if any one was to enjoy the advantages of mechanical production, more and more men and women would have to spend more and more time as mere operatives of impersonal machines. Fully automated production, the electronic revolution, has made Morris's 'Utopia' a much more practical and feasible proposition.

Today, if we wanted, we could indeed establish a productive system, an economy, which permitted the production of objects of primary necessity by machine, and allowed the arts to flourish. The initiation of such a society, however, requires a complete re-orientation of political and economic objectives: one has to be pessimistic and say that is most unlikely; we are much more likely to end up with something like Orwell's *1984*.

So, no, I don't think we are anywhere near the vision of the world Morris put forward in *News from Nowhere*; but I think you are absolutely right in suggesting that what is important about that vision is the fact that Morris looked towards a world in which everyone would be able to engage in aesthetic, artistic and ornamental work. He thought that revolutionary socialism would bring such a world about. In this, belief, of course, he was wrong. This would certainly have led him—had he lived— either to have rejected socialism, or to have argued that it needed to be rethought from the roots up: that, I believe, is the choice which faces us, today.

COLIN SYMES:

Throughout your writings you seem to rage against an art which portrays or hints at human degradation. Much of your scorn is directed towards artists who you have said, following Leavis, do 'dirt on life'. You cite Richard Hamilton's scatological exercises as a case in point. If you'll excuse the pun, such art is simply shit: just another example of the ubiquitous 'kenosis' you see as being prevalent in postmodernist forms. In the light of such comments, can you be specific as to what it is you value in art? Is it a necessary criterion of good art that it be, in the Leavisite

sense, morally uplifting, a profound bearer of values strikingly absent in the epoch of capitalism and nuclear destruction?

PETER FULLER

Good art is rooted in aesthetically satisfying, sensuous experience: in beautiful colours, forms, sounds, shapes, rhythms and patterns. But great art rises above sensual gratification: it has—in the fullest sense of that much abused word—a moral dimension; great art involves imaginative transformation—of the highest order—of the data given to the senses. Of course, art can deal with degrading or despairing themes, and still be great: think of Rouault's paintings of Parisian whores; Soutine's carcasses of beef; or Poussin's winter, an image of the destruction of everything in the flood. But in such works a redemption through form has always taken place: the beauty of the handling, and composition, profers that hope which seems to be denied by the subject matter. Like Marcuse, I value the participation of good art in the construction of the 'cosmos of hope'—and I believe that, for this to happen, it is necessary that art should remain faithful to its own aesthetic dimension. In this way, yes, art can be, as you put it, 'a profound bearer of values strikingly absent in the epoch of capitalism and nuclear destruction.'

COLIN SYMES:

In line with your 'radically conservative' vision, you have admonished recent trends in art education. The anaesthetising elements of contemporary culture, you say, have spread to colleges of art. You are equally critical of the child-art movement, which, though celebrating creativity, gives the impression that all art 'aspires to the condition of infantilism'. Media studies, design courses ... you condemn all the paraphernalia of recent art education. Like some aesthetic Luddite, you seem to want to return art education to the good old days of life classes, drawings, traditional arts and crafts. Could you say something more about your views on art education and why it is you consider that traditional art training was superior to that currently purveyed?

PETER FULLER:

An education in art should be based on *drawing*. I think students should learn to draw from the figure and from the whole gamut of natural forms. They should also be taught how to construct illusions of space in two dimensions, i.e., they should learn about perspective. Art history should be based much more on the history of techniques; a ten-year moratorium on the teaching of art history from slides would probably help. I further believe that art students should receive much less, if any, popular sociology and media studies, and much more education in zoology, botany, anatomy, metereology, and geography. I also favour the introduction of courses of practical aesthetics: i.e., courses which encourage art students to think about how they make aesthetic judgments, and what they mean when they call a work good, or bad. (No one who has a background in the Power Institute should be allowed to teach on such courses.)

I do not know what you mean when you say that this is the position of 'an aesthetic Luddite'. The attempts to 'modernise' art education, to make it 'relevant' to the Modern Age, etc., have themselves conspicuously failed. Basic Design, and related post-second world war methods in art education, all seem to have involved the same fallacious modernist assumption—that, to be good, art must 'progress', like technology. But I hope I have said enough to indicate that, whatever technology may do, the roots of good art lie in aspects of human experience which do not change greatly from one civilisation to another. Henry Moore spent much more time studying Aztec and Abyssinian sculpture in the British Museum than he gave to looking at advertisements, or mechanical processes. Nonetheless, he also produced some of this century's finest sculptures. I think art education should reflect the conservationist character of the aesthetic pursuit: art education should preserve, foster and develop those skills, conventions and traditions peculiar to the practice and appreciation of the Fine Arts. It should not be a party to the eradication of art by the mega-visual torrent.

COLIN SYMES:

Can you talk a little about state patronage? One of the articles in this issue deals with the role of the cultural worker in Cuba. Artists are all in the employ of the state; they have a guaranteed livelihood. Art enjoys more funding than defence. Presumably, you would not object to that! On the other hand, you have said that state patronage (in all its diverse and indirect forms) has led to an unparalleled decadence in art, decadence in this sense, meaning unparalleled aesthetic incest. But what alternatives are there to state patronage, particularly in the socialist state?

PETER FULLER:

I am not against state patronage of the arts: on the contrary, I believe the state's involvement in the arts should be much more extensive, pervasive, and influential than it is at present. I am, however, against both the forms and the content of the present system of state patronage in Britain. This is based on John Maynard Keynes's policies, spelled out immediately after the last war. Keynes wanted to see a new 'Golden Age; of the arts, in the West, comparable to the great moment of Greek civilisation. Keynes elaborated the 'hands-off' approach, which involves giving artists money simply to be artists, and, as he put it, following where they lead. He felt this would expose the repressive shabbiness of what he called *art officiel* in Eastern Europe.

This 'hands-off' approach has been endorsed ever since by both left and right— and bolstered with the rhetoric of 'artistic freedom', etc. But it has conspicuously failed to foster anything except decadence in the west. I believe that it is the duty of governments to exert *patronage*—rather than to hand out money, as additional welfare, to individuals who describe themselves as artists for them to do what they like with. Patronage involves the affirmation of values: it necessitates discrimination. This fact can be shirked neither through the left-wing appeal to democracy, nor

the right-wing appeal to 'individual freedom'. This does not mean, of course that if patronage is discriminatory, it is necessarily good! I differ from many socialists, and, incidentally, from many of those on the New Right, in that I do not feel a knee-jerk opposition to all forms of social control. I am in favour of *good* social control: the content is decisive. I favour the sort of relationship to the arts which the state has to medicine through the National Health Service. There's no question there of giving doctors money to do what they like with: and no question, either of the infringement of professional freedoms. At present, government arts policy (such as it is) encourages no one to develop their creative and aesthetic potential. To sum up: I believe state patronage is essential—now, and in any imaginable social future; but the present *forms* of state patronage are worse than useless. They positively hinder aesthetic renewal. Governments have to affirm and implement the aesthetic values for which they stand, and be judged (among other things) by them.

COLIN SYMES:

In a discussion you had with Terry Eagleton, published in the *New Left Review*, you broach the whole issue of popular culture. Your definition of such culture is interesting in that it eschews the usual categories of popular culture: television, advertising, spectacles. True popular culture, you insist, involves an aesthetic dimension (that phrase again), and name goldfish breeding as a case in point. Will you say something about popular culture, particularly its relationship to high (if that is not too value-laden an epithet) culture.

PETER FULLER:

The distinction I draw between popular culture, and spectacle is in no way original. Raymond Williams was one of many who pointed it out long before me. Spectacle is something imposed upon people, or piped onto them: they receive it passively, and they do not participate, affectively, physically, or culturally in its creation. Advertising, of course, is cynically produced: no one believes that using one brand of detergent rather than another actually deepens family love. To describe such phenomena as 'popular' is simply to distort them. There are pursuits which can legitimately be described as popular culture, however: goldfish-breeding is just one, but there are literally thousands of comparable hobbyist and horticultural pursuits, ranging from wood-working, through dog-breeding, to rose-growing. How do these activities relate to high culture? In 'Aesthetics After Modernism', the Power Lecture I delivered in 1982,[10] I argued that once the aesthetic dimension was a component in most human activities: from the manufacture of items of dress, to functional objects, and ritual preparations for war, or harvesting. There was always an aspect of such work which was not functional: which was aesthetic ornamental and symbolic. And the individual, however humble or unskilled, could participate directly in this aesthetic expression—thus manifesting, at one and the same time, both his own individuality, and the unity of the tribe, or community.

Two forces, historically, led to the erosion of the aesthetic dimension in the lives

of ordinary men and women. One was the gradual dissolution of the kind of shared symbolic order which a religion once provided; this, of course, was of vital importance in, say, the creation of the great cathedrals in the west. The other was the way in which the onslaught of industrialisation transformed, and de-aestheticised, human work.

In this situation, the aesthetic dimension was driven out of everyday, productive life: it came to reside, at one end, in the grand illusions of the painter ... And, at the other, it persisted as a rump, residue or remnant in goldfish-breeding, woodworking, and rose-growing. I.e., those pursuits which genuinely constitute an alternative popular culture, rather than a mass spectacle. I am in favour of forms of social life which encourage *both* ends of this spectrum: goldfish-breeding and Grand Opera, if you like. I am against the unholy alliance of the cultural avant-garde, and the 'progressive' right which is leading to the decadence of all these things, and to that condition I have elsewhere described as cultural General Anaesthesia.

NOTES AND REFERENCES

1. Reproduced in *Beyond the Crisis in Art* (London: Writers and Readers, 1980) as 'In Defence of Art', pp. 230–64.
2. London: Merlin Press, 1978.
3. *William Morris: From Romantic to Revolutionary* (London: Merlin Press, 1977).
4. A good collection of Morris's writings in Briggs, A. (ed.), *William Morris: Selected Writings and Designs* (Hammondsworth: Penguin, 1973).
5. Gill's *Art* (London: Bodley Head, 1949), especially the chapter 'Art in the Twentieth Century', pp. 95–108.
6. *The Aesthetic Dimension: Toward a Critique of Marxist Aesthetics* (Boston: Beacon Press, 1978).
7. See especially Walker's *Art And The Age of Mass Media* (London: Pluto Press, 1983).
8. Timpanaro's principal work on Marxism in *On Materialism* (London: New Left Books, 1978). An essay on him by Peter Fuller is contained in *The Naked Artist*.
9. See above, pp. 17–30.
10. See above, pp. 1–44.

APPENDIX

Australia—The French Discovery of 1983

THE LATE JILL BRADSHAW

In Paris the year 1983 has already been christened the year of Australia and, as one writer puts it, 'this year, kangaroo is the height of fashion' ('La mode, cet hiver, se portera kangourou').[1] The exhibition held in the ARC Gallery (at the Musee d'Art Moderne de la Ville de Paris) could not have been organised at a more opportune moment. Already, the *Mad Max* films such as *Newsfront, The Man from Snowy River (L'Homme de la Riviere de'Argent)*, and those by Peter Weir (*Picnic at Hanging Rock, The Wave* and *The Year of Living Dangerously*), had stimulated considerable interest in the Australian film industry, and at the same time awakened an almost insatiable curiosity about Australia, its history, its culture and its occupants.[2] Then the Australian victory at Newport riveted attention on Australian sporting prowess: newspaper and T.V. headlines trumpeted the Australian success and openly took the side of the Australians in their battle against American wealth, American arrogance and the American establishment. The Perth millionnaire, Alan Bond, who had invested a meagre four million dollars in his yacht, was depicted as the 'little man', gamely battling against the American 'Goliath', 'Big' Conner.[3] However, the exploits of 'White Australia' pale into insignifance when one considers the impact on the French press and public, of the discovery of Aboriginal Australia.[4] In fact, one newspaper suggests, in a graphic image, that the cohabitation of contemporary Australian art and the Aboriginal Ground painting (in the context of the Museum of Modern Art) is as 'incongruous and exciting' as the construction of a 'motel casino' in the vicinity of the sacred site of Ayer's Rock in the Northern Territory.[5] It is obvious that without the aboriginal participation, the dance spectacle at the 'Bouffes du Nord', the ground painting by the Walpiri tribe at the Museum of Modern Art, the aboriginal video programme and the acrylic paintings at the Australian Embassy, the Australian contribution to the Paris Autumn Festival would have been almost a 'non-event'. Probably, the exhibition of contemporary Australian art would have gone virtually unnoticed by the Parisian public, satiated with 'avant-garde' art, and secure in the knowledge of the centrality of Paris

59

to 'mainstream' culture—even if the current has shifted slightly in the direction of New York.

The Aboriginal contribution gave the Australian exhibition a chronological, cultural and anthropological dimension which attracted a wider public than that which habitually frequents exhibitions of contemporary art. One can argue that aboriginal culture is just as much contemporary as it is ancient, but the aboriginal artefacts created a different awareness of the Australian continent, no longer viewed by the French just as an outpost of the British Empire or of a moribund Commonwealth (whose special ties with Great Britain threaten the stability of the European Common Market). Suddenly writers began to speak of its geological age as an ancient landmass colonised as long as 30–40 thousand years ago by the Aborigines who now exist only as an oppressed minority of 150,000 people living on the fringe of the cities.[6] What has become apparent to the French is the contrast between the two cultures inhabiting the 'new' and the 'ancient' continent and this has altered the perspective in which Australia has traditionally been viewed by the French who have tended to glamorise it as the 'last frontier', a country of adventure, full of vitality and dynamism. The impact of the 'discovery of Australia' has prompted some journalists to allude, in characteristically cartesian terms, to 'apartheid' Australia and to invoke, by analogy, the comparison with South Africa and the U.S.A. which both have a history of colonial oppression. Certain press headlines operate on this assumption. In the newspaper *La Liberation*, Jean-Pierre Thibaudat makes a perjorative play on the word 'reserve': 'Les Aborigènes sortent de leur rèserve' (The Aborigines abandon their reservations),[7] and Fabien Gruhier, writing for *Le Nouvel Observateur*, calls the Autumn Festival the 'Season of the Abos', thus drawing attention to the derogatory way in which, at least in the past, Australians referred to the original inhabitants of their country.[8]

It is unlikely that Gruhier is unaware of the racist connotations of the word 'abo' because the magazine for which he writes introduces him as the only journalist in the world to have been admitted into Gan-Gan territory. He bases his article on the theme of the 'noble savage' (an invention of Jean-Jacques Rousseau who argued that the benefits of civilisation were illusory) and the refusal by the aborigines to allow themselves to be 'corrupted' by progress. Gruhier goes on to describe the curious reversal, which has occurred in Australia, of the usual pattern of colonisation: whereas in most countries colonised by an advanced Western civilisation the inhabitants have been irresistibly attracted to a technologically-superior culture and have been not only converted to the Christian religion but also enslaved to a consumer society, the Aborigines have made a deliberate choice to revert to tribal customs and to return to their ancestral lands. Contact with white civilisation—religious indoctrination by the white missionaries ('évangélisés et anglicisés'), enforced recruitment into the army during the second world war—inevitably engendered not only a sense of frustration, but also anger and disillusionment. They abandoned the 'bidonvilles' (shanty-towns) where they had been herded after the war, and gradually resumed their ancestral territories and the struggle for the recognition of their

legal rights over these lands, which they have gradually wrested from the Australian government. Gruhier emphasises, justifiably, the rejection by the aborigines of the values of 20th century Western society, their refusal to invest in its materialism and their determined adherence to the spiritual tradition which they have evolved over a period of 40,000 years and lost in the last 200. Obviously, the resistance of the aboriginal people to the dominance of Western culture, and the paradoxical nature of their decision to revert to tribal life after 200 years of cohabitation with the whites, provide an *a posteriori* illustration of Rousseau's thought, and have captured the jaded imagination of these Europeans discovering Australia for the first time in 1983. In the *Social Contact*, Rousseau maintained that society as we know it does not signify 'progress', but instead man's enslavement and the loss of his natural liberties and autonomy. Rousseau's philosophy infected a whole generation with a profound nostalgia for a lost heroic age and Gruhier quotes Captain Cook whose comments on the aborigines reflected the European tendency, in the 18th century, to idealise the 'savage' who was 'naturally' virtuous, uncorrupted by society. 'The natives of Australia have a miserable appearance. But, in fact, they are much happier than we Europeans, being totally ignorant of the notion of luxury (le superflu), and also of the 'necessary' commodities. In short, they seemed to attach no value whatsoever to what we gave them, and did not wish to part with anything that they themselves owned.[9]

Although Gruhier's article presents no real distortion of the facts concerning the situation of the aborigines (he quotes extensively from Lance Bennet), it is structured around certain philosophical stereotypes which recur, in the form of outworn platitudes, in *Le Figaro*. Here the writer describes Australia as 'an immense paradise', 'Ancient Albion' (Old Albion).[10] It is inevitable that articles such as these, which appear in popular weekend magazines, should reflect a certain journalistic bias and be tendentious in their presentation. Likewise, the headline in *La Libération*, 'Un envoûtment par minute' ('A spell-binding performance'), suggest the enthusiasm and fascination with which the French public, critics and spectators alike, responded to the aboriginal dances and music.[11] Perhaps the most judicious and balanced appreciation of the antipodean aboriginal music appears in *Le Monde de la Musique*.[12] The author, Jean Nattiez, expresses certain well-founded reservations about the 'legitimacy' of the spectacle at 'les Bouffes du Nord'. Firstly, he discusses the ethical or moral question raised by the transportation of this 'primitive' or tribal people to Paris. Should the aborigines be 'exhibited' for the entertainment of the Parisian intelligentsia? Secondly, what validity does this ethnic music retain when it is performed 'out of context'? He suggests that the presentation of aboriginal music and dance in the form of a 'spectacle' causes a profound alteration in their meaning, since this music was not intended for reception by a western concert audience nor to fulfil certain expectations of enjoyment. It relies on a context for the acquisition of meaning: but, even if the westerner is aware of the context which confers social or religious significance on certain dances, it is inevitable that he should apply his own criteria of aesthetic judgment in assessing them. This does

not exclude the possibility that such music may possess musical qualities such as those usually distinguished by westerners, but these qualities may not necessarily be equated with the criteria for which the music is valued by its indigenous practitioners. In considering aboriginal music, Nattiez discusses a number of fundamental issues which preoccupy the musicologist: the variability, from culture to culture, in the concept of 'le Beau' (Beauty): the error, sometimes committed by ethnologists, of believing that primitive art is static, characterised by its uniformity. In fact, primitive music is equally subject to changes in 'taste', and may be just as heterogeneous and complex as western music, whilst at the same time reflecting the dominant ideas of the age (i.e. prevailing taste) just as in western societies. In conclusion, he cautions the Parisians against certain misconceptions which could arise from the encounter with aboriginal music and dance. It is inconceivable that aboriginal art should not be conditioned by their mode of life and their religious beliefs; likewise, the reactions of the Parisians, confronted with ethnic art, cannot but be different from those of the performers immersed in their own culture.

More than any of her colleagues, Marjorie Alessandri has attempted to reconcile, from an intellectual point of view, the contrasts apparent in contemporary Australia and reflected in the dichotomous nature of the exhibition in Paris. In an article entitled 'Australia Now',[13] she attempts to go beyond the usual clichés used to summarise 'Oz Land' (le pays d'Oz) and its inhabitants—a country of surfers and rockers, of kangaroos and primaeval landscapes, of sportsmen and beer-drinkers, and of 'Mad Max' type violence. The pride in sporting achievements, the emergence of an independent film industry, are all, according to this writer, symptomatic of a new self-awareness on the part of Australians. In seeking to explain the sudden 'explosion' of Australia, she reiterates the idea—which was one of the themes of the Sydney Biennale in 1979 and again in 1982—that Australia is becoming aware of her own identity and that her achievements in the arts, in cinema, in music, and even the sudden interest in her own 'history' (the settlers), are an assertion of a cultural identity which rejects all forms of cultural imperialism exercised by America and also by Europe (the Old World). Whereas, in the past, Australian artists applied for grants to study in the U.S.A. or in England, they are now beginning to work, to create and seek inspiration in their own country. This explains the sudden cultural effervescence in Australia. Australians, infected by a sense of boredom and a certain discontent with their suburban, middle-class existence—which sport and beer-drinking are unable to dispel—are seeking 'un supplément d'ame' in the arts, and even in the spiritual traditions of the aborigines. Thus, Alessandri observes, the aborigines pose (for the 'white' Australians) a number of urgent racial, social and political problems, but they also provide a source of wonder and fascination, a fabulous store of mystery (un tabuleux mystère, source d'étonnement et de fascination'). Artists and intellectuals who have succumbed to the fascination of the aboriginal culture have thus sought in its traditions a form of spirituality, which they lack, and an 'ecological' harmony with the land, which the aborigines have never lost. As she remarks with admirable perception, it is partially as a result of white, middle-class guilt that

aborigines have suddenly become fashionable in Australia, rocketing to stardom as a result of the plagiarisms of their culture practised by Peter Weir (*The Wave*), rock groups like 'The Goannas', and fashion designers like Linda Jackson and Jenny Kee (who use 'earth' colours in their textiles). She concludes that the arrival of the aborigines in Paris must be 'read' or interpreted as the sign of this prehistoric people's determination to 'enter History' ('entrer dans l'Histoire').

Any attempt to summarise the French reaction to the Australian exhibition in Paris is a hazardous venture. There is a serious danger that it will lead only to a number of over-generalisations, similar to many of the radical statements made by the French themselves about Australia. However, in her introduction to the Australian exhibition, for which she acted as the principal organiser, Suzanne Pagé[14] concedes that the 'myth' of Australia still exerts an undeniable attraction for the Europeans and conditions their response to this antipodean land: 'fantasies of adventure and romance centred around a heroic vision of Australia (a new version of the positive hero): a return to sources, the last frontier, the last place where adventure is still possible, the final refuge for a death-dealing civilisation haunted by the spectre of universal disaster.[15] But although Pagé announces her intention to dismantle the myth, she goes on to describe the appeal of Australia in terms of 'stark contrasts', thereby reasserting the myth in the well known form of the 'pathetic fallacy' in which the landscape is made to reflect the emotions of the viewer: 'The first impression is of excitement and optimism, bound up with a tremendous feeling of energy, the vastness and savage beauty of landscapes, the enormous and untapped potential of a new nation, and further stimulated by stark contrasts—sunshine and the implacable harshness of a murderous climate . . .'.[16] The rhetoric of contrasts allows Paée to establish a series of antitheses which encapsulate the experience of Australia: 'the huge area of the country and the low population density (about 15 million); immense uncultivated or desert regions and intense urbanisation in population centres stretching out as interminable suburbs around a few anchor points along the coastline . . .'. She juxtaposes the feeling of freedom, and physical freedom which allows casualness of dress, the youth and permissiveness of this society, with 'the desire for comfort and a disconcerting conformism'. She emphasises the modernity of this society, a 'modernity' which appears, 'in its most fleeting and superficial guises', in the capacity of Australian society to assimilate a universal mass culture, to adapt to the most advanced technology, particularly information transmission. However, in contrast to this white contrast to this white profligacy, there stands, according to Paée the ancient aboriginal culture. 'At the centre of this mass of contradictions, multifarious, unstable (post-war immigration brought people from many lands), Aboriginal society, divided as it is into many tribes, stands with serene permanence and timeless transcendence based on a religious, initiated gerontocracy, custodian of a rich cultural heritage, where any notion of property is foreign, wanting only to live on the land where it belongs, according to the law of Dreamtime'.[17] By implication, then, 'White Australia' is superficial, secular (preoccupied with time), materialistic, acquisitive; it is an usurper in this timeless land, racist to the point of apartheid.

The French tendency to indulge in philosophical dialectics has thus determined the structure and the presentation of the exhibition in terms of contrast and dichotomies. The inclination to classify, and therefore to establish a hierarchy, perhaps explains why the exhibition organisers seem to view Australia in terms of opposites, as a series of contradictions, as two worlds 'almost totally ignorant of each other'. Marxist thought provides a convenient framework (hypothesis, antithesis, synthesis) which facilitates the reduction of complexity to a series of manipulable units. It is evident that as a result of a form of philosophical indoctrination, which places great emphasis on the ability to conceptualise and organise one's arguments, the French are adept in constructing systems of thought based on a rhetoric of opposites. In this context, whites in Australia become blacker than usual, and the aborigines even 'whiter' than their white oppressors: Australians no longer inhabit Australia, but a land of absolutes. Thus, the French organisers have adopted a somewhat self-congratulatory stance, insofar as they have assumed for themselves the traditional rôle which France has always claimed—that of 'mediator', bringing a civilised and civilising influence to the arena of racial conflict. The boast that this French initiative of holding an exhibition in Paris has facilitated the encounter between 'white' and 'aboriginal' Australians, who would not otherwise have had the opportunity of even meeting one another, has recurred with almost monotonous frequency in official speeches and addresses. It is repeated in the lecture tour of the exhibition, which represents the official version or view presented to the public. It is strange that the French should adopt this attitude of moral superiority at a time when France itself is extremely divided over racial problems and outbursts of racial violence, which occurred during the last summer in the 'nouvelles villes' where there is a high concentration of workers and their families from the Maghreb. This violence (at Dreux, for example) has reached such a level that it has become a very real political issue which the 'Right' has used to great political advantage in the latest municipal elections.

Official statements about the exhibition reinforce the idea that France assumes the role of a dominant culture, especially since the introduction to the catalogue indicates that one of the principal aims in bringing the Australians to Paris was 'to arouse in this country and amongst its artists' a more informed curiosity about France. Australians would acquire a knowledge of France beyond the stereotyped clichés. In many ways the French reaction conforms to a philosophical model evolved by Michel de Montaigne in his *Essais*. Montaigne witnessed the colonisation of the Americas by the Spanish in the 16th century. He expressed his outrage at the brutality and the inhumanity of the followers of Cortex, who tortured the Indians and perpetrated the most criminal acts of barbaric savagery against the so-called 'savages'. In his eyes the conduct of the Europeans was inhuman, far more barbaric than that of the barbarian and 'uncivilised' Indians. Unlike many contemporary writers of the time, who equated the Indians with savages and barbarians, and labelled them inferior and ignorant, Montaigne reversed their terminology which presupposed an attitude of cultural superiority. Tzvetan Todorov has analysed the

writings of some of these Spanish authors and drawn up a table (see below) demonstrating the philosophical dichotomies on which their assumption of cultural dominance is based:

$$\frac{\text{Indiens}}{\text{Espagnols}} = \frac{\text{enfants (fils)}}{\text{adultes (pére)}} = \frac{\text{femmes (épouse)}}{\text{hommes (époux)}} = \frac{\text{animaux (singes)}}{\text{humains}} =$$

$$\frac{\text{férocité}}{\text{clémence}} = \frac{\text{intempérance}}{\text{tempérance}} = \frac{\text{matière}}{\text{forme}} = \frac{\text{corps}}{\text{âme}} = \frac{\text{appétit}}{\text{raison}} = \frac{\text{mal}}{\text{bien}}$$

[18]

Montaigne, who apparently realised that it is the nature of the ideological framework which determines the formulation of philosophical propositions, applied the terms which, for the Spanish, characterised the Indians, to the behaviour of the Spaniards. The treatment of the Indians, which the Spanish writers saw as justifiable, thus becomes intolerable and inhuman, and hence injustifiable. The French, four centuries after Montaigne, still seem to rely upon such simplistic dichotomies, even if unconsciously, and the discovery of Australia which they have made in 1983 has led to an 'unqualified' infatuation with Aboriginal Australia. It perhaps explains why they have placed the emphasis on the ethnic aboriginal culture of Australia, forgetful of the fact that Australia has had to live with its 'conquest' for the last 200 years, and that its ideology has had to evolve beyond the stage of linguistic paradox. One writer, however, does ask himself, with refreshing candour, why the Europeans are so blinded by their guilt that they are incapable of admitting that the aboriginal music and dances are boring. The primitive 'Arcadia' of Australia is just as sterile as the Parisian jungle.[19]

One of the most novel suggestions to emerge from the writings of both French and Australian commentators on the Australian exhibition is that, in order to revitalise Australian art and endow it with a new kind of spirituality, contemporary artists are turning increasingly towards aboriginal art and its traditions. Marjorie Alessandri presents this case most strongly, suggesting that the Australian fascination with aboriginal culture is motivated by an awareness of the sterility of white, middle-class culture and its failure to provide spiritual values.

A preoccupation with landscape has not ceased to be one of the characteristic features of Australian art. The earliest painters tried to domesticate the strangeness of this unfamiliar land by clothing it with forests of oak and by re-ordering its vistas into a vision of bucolic peace. Nolan, in turn, tried to reverse the process of domestication by depicting the alien-ness of the desert void but he also, as Juan Davila suggests in speaking of the West-Australian landscape, only parsitised this landscape, projecting upon it his own anxiety in a negative form of the 'pathetic fallacy': 'The long-standing anxiety of Australians confronting the landscape indicates a problem of identity. The void of the land is forced to signify, ignoring the suture that it offers'.[20]

Recent landscape art in Australia can be criticised as being narcissistic and solipsistic, revealing little to the viewer other than the paranoia of the artist and his refusal to accept a meaningless landscape. One can even characterise landscape art in Australia as the visual rendering of the manifest inability of the European tradition to cope with, or become integrated with, the Australian landscape which represents the ultimate insult: it is neither hostile nor even indifferent to man's presence, but totally oblivious. Man's attempt to domesticate this landscape has been conspicuously unsuccessful—and the failure to make of the landscape a self-supporting idiom (similar to the English tradition on which it is based) explains much of the barrenness of Australian art. The tendency of Australian artists to gaze 'inland', and to try to invest this landscape with meaning, whilst viewing it from the safety of the city—to which they return after their incursions into the centre—represents a refusal to come to terms with the environment that European society has constructed, the built environment. Landscape art can thus be seen as a form of 'escapism', epitomising the abdication of the artist and his inability to accept his own cultural insertion into the social and political structures which determine his own existence.

It is perhaps significant that recently there has been a recrudescence of a form of landscape art, which focuses on a deeper involvement with prehistoric Australia, or the 'megalithic' tradition.[21] A number of artists have identified with the Australian landscape in a way that attempts to mirror or reproduce, at the individual or private level, what 'whites' conceive to be the aboriginal relationship with the land. The empathy with the land which the aborigines have evolved over 40,000 years finds expression in their religious beliefs, in the veneration of sacred sites, which they perceived as a physical 'grid' externalising their spiritual or mythical ties with their land. The creation, by Australians of European descent, of art forms intent on revealing the sacred rhythms of the desert landscape can never exceed the level of a private mythology, no matter how deeply or sincerely it is felt and expressed. Thus, although it is tempting to agree with certain critics that Australian art must draw upon the resources of aboriginal Australia, one may argue that it is time that Australian artists showed an equal concern with the realities of their own condition expressed in the marginal European society which is Australia. Just as landscape painting has proven to be an escape, this preoccupation with ancient aboriginal art and sites may yet again prove to be another escapist tendency—which romanticizes or idealizes the aboriginal bond with the land—taking Australian artists from the social landscape which they now inhabit. The vision of Arcadia has been obliterated, and can never be regained, because the whites themselves are responsible for the rupture which has occurred, between themselves and the land, as a result of their rejection of the aborigines, the only people who can ever really claim to know the continent.

The works which are exhibited at the Musée d'Art Moderne de la Ville de Paris are, however, undeniably concerned with modernity and show a familiarity with international trends in contemporary art. When questioned, very few French viewers

were able to identify any specific features which, for them, characterised this work as peculiarly Australian. If, indeed, any difference was perceptible, it was a certain 'violence' which distinguished it from European contemporary art. Some felt this violence reflected the force inherent in the landscape itself, whilst others felt that it expressed the violence and aggressivity which have become synonymous with contemporary urban existence. In voicing this opinion, they provided a corroboration of John Bursill's interpretation of his own work which in fact impressed many viewers by its strength and childish dynamism. The official guides in the gallery have adopted the standard approach, analysing the individual works on display in terms of their relationship to the Modernist tradition. John Nixon's crosses on paper and canvas are interpreted in terms of a dependency on Malevich, but promoting a critical, self-reflexive meditation on the 20th century modernist culture; Peter Kennedy's 'banners' are viewed as an expression of a deeply-felt political commitment.

Richard Dunn's texts and images are predictably 'read' in terms of recent developments in semiotic analysis which concentrate on the relationships between signifiers, rather than signifiers themselves. Peter Booth's canvasses embody a form of expressionism, containing elements reminiscent of Bosch, Brueghel and Ensor, and also of certain literary influences such as that of Dostoievsky. In introducing Mike Parr's installation work, one guide mentioned that Parr and Kennedy owed much to conceptual and performance art in the U.S.A. and Europe which they 'discovered' in the early 70s: this occasioned the remark, echoing Suzanne Pagé in the catalogue that, despite the obvious dynamism of their work, Australians often display a 'disconcerting conformism'. Parr's work, because of its French literary associations, was dealt with rather summarily. His use of Antonin Artaud's chant 'Culture Indienne', an abstract and totally obscure text, provides him with a theme or literary parallel for a series of portraits rendered in anamorphic distortion. Parr's work was interpreted as a metaphor, transcribing into visual terms the dilemma experienced by Artaud, the rupture between the creative self and the objective reality. Juan Davila's work was judged representative of the recent POPISM movement in Australia. His canvasses were 'read' as critiques of a media-dominated society, with their overt references to 'pop' art borrowings, their dependency on cliché, comic strips, the media (T.V. and adverts) and on reproductions of works of art which, until recently, Australians 'consumed' in the form of pastiches. One guide, proving that she had digested the official catalogue, suggested that Davila dismantles the current 'codes' which operate to camouflage the fundamental cultural void in Australia by situating well-known comic-strip heroes and American film stars in a mock Alpine landscape, thereby parodying early English renderings of the Australian 'bush'.

France Huser unhesitatingly qualifies the contemporary Australian exhibition as derivative: the Australian artists 'hungrily' assimilate and emulate the ideas and trends which have originated in Europe and the U.S.A., thus offering an indiscriminating and confused homage to Bosch and Goya, the media (T.V. and advertisements), Warhol, Coca Cola and Mona Lisa, to the asceticism of conceptual art and the rawness of expressionism.[22] It is not difficult to guess to whom each of these

phrases alludes. Nevertheless, Huser also insists upon the unusual violence which pervades this Australian art and speculates that the harsh and strident colours characteristic of the new expressionism that has implanted itself in Australia find their equivalent in the 'excès' (excesses) of the Australian landscape itself.

The reaction of one French visitor to the Gallery provides an apt if somewhat obvious conclusion to the exbibition. Having watched Ken Unsworth's performance, *Rhythms of Childhood*, she was visibly moved by its evocative power, its power to suggest feelings of nostalgia, the sinister terrors of childhood, the imminence of death and its sense of oppression.[23] These same impressions were echoed by many other viewers of the piece; one person reiterating the words 'horrible', 'unbearable'.[24] Thus, in response to the suggestion that it might be possible to isolate certain features as characteristic of Australian art in general, was expressed the view that any attempt to localise the artist, or define the work in terms of the artist's nationality, could have no relevance to the production of art. Art speaks a universal language, and on condition that it communicates or offers a potential space for communication, it cannot be defined in terms of geography.[25] This is perhaps an important conclusion especially since, as recently as 1979, Air France advertisements mysteriously left out Australia in their map of the world! So long as Australians continue to look to Europe and America for confirmation of their own identity, they will never exist as anything but a peripheral culture, forever condemned to be an 'exotic' and alien people. As Juan Davila suggests,[26] they will only achieve identity through the assertion of their 'otherness', but not through insistence on 'difference'.

Paris, October 1983.

NOTES

1. Fabien Gruhier, 'La Saison des Abos', *Le Nouvel Observateur*, No. 986, 30 Sept.-6 Oct. 1983, p. 85.
2. 'Le Cinéma Australien', in *La Revue du Cinéma*, Nos 385, 386, 387, juillet aôut septembre et octobre 1983.
3. Gérard Petitjean, 'Tant va la Coupe à l'Eau', *Le Nouvel Observateur*, No. 986, 30 sept.-6 oct. 1983, pp. 87–8.
4. 'L'Australie Découverte', *Le Monde de la Musique*, No. 60, octobre 1983.
5. Jean Pierre Thibaudat, 'Les Aborignès sortent de leur Réserve', *La Libération*, samedi 8 octobre 1983, p. 20.
6. Fabien Gruhier, *ibid*.
7. Jean-Pierre Thibaudat, *ibid*.
8. Fabien Gruhier, *ibid*.
9. Fabien Gruhier, *ibid*.
10. Patrice Méritens, 'L'Australie, l'île continent du bout du monde', *Le Figaro Magazine*, samedi 8 octobre, 1983.
11. Chantal Aubry, 'Un Envoûtement par Minute', *La Libération*, samedi 8 octobre, 1983.
12. Jean Nattiez, 'Le Beau et le Primitif', *Le Monde de la Musique*, No. 60, octobre 1983.
13. Marjorie Alessandri, 'Australia Now!' *Le Matin*, mercredi 5 octobre 1983, p. 27.

14. Suzanne Pagé, Introduction to the Exhibition Catalogue, *D'Un Autre Continent: L'Australie, le Rêve et le Réel*, ARC Musée d'Art Moderne de la Ville de Paris, 4 oct.- 4 décembre 1983, pp. 9–15.
15. Suzanne Pagé, *ibid.*, p. 10.
16. Suzanne Pagé, *ibid.*, p. 10.
17. Suzanne Pagé, *ibid.*, p. 11.
18. Tzvetan Todorov, *La Conquête de l'Amérique (la Question de l'Autre)*, Editions du Seuil, Paris, 1983, p. 159.

$$\frac{\text{Indians}}{\text{Spaniards}} = \frac{\text{children (son)}}{\text{adults (father)}} = \frac{\text{women (wife)}}{\text{man (husband)}} = \frac{\text{animals (monkeys)}}{\text{humans}} =$$

$$\frac{\text{ferocity}}{\text{clemency}} = \frac{\text{intemperance}}{\text{temperance}} = \frac{\text{matter}}{\text{form}} = \frac{\text{body}}{\text{soul}} = \frac{\text{instinct}}{\text{reason}} = \frac{\text{evil}}{\text{good}}$$

19. Jacques Drillon, 'Des Shows cachés depuis la Création du Monde', *Le Nouvel Observateur*, 21–27 octobre 1983, p. 108.
20. Juan Davila, 'Landscape Art in Western Australia', *Praxis M*, No. 2, July 1983.
21. Daniel Thomas, 'Von Guérard, Brian Blanchflower and the Megalithic Tradition', Octagon Lecture, University of Western Australia, 1983.
22. France Huser, 'Mona Lisa, Warhol et les Walpiri', *Le Nouvel Observateur*, No. 989, 21–27 octobre 1983, p. 108.
23. 'Je ne peux pas rester. C'est insupportable au bout de cinq minutes parce qu'il y avait une trop grande nostalgie. Le martèlement, en fait, le son, est complètement insupportable. L'immobilité totale qui rend insupportable. La mort, quoi? Est-ce qu'il bouge finalement? La performance que j'ai vue, je ne l'ai pas liée à la situation historique politique de l'Australie. Je l'ai liée plus à un humain, une personne en '83 qui regarde le passé, l'éternel passé, l'entrance, quoi? Il y a une expression qui est complètement internationale.'
24. 'C'est bouleversant, quelque chose d'oppressant. C'est horrible. C'est très angoissant. Très angoissant ... C'est l'expression du néant. Enfin. c'est comme ça que je le vois. Avec cette poupée qui est morte, inanimée, enfin, une image de la mort. Ça m'a fait peur, hein?'
25. 'L'art, c'est quelque chose d'universel. Ça ne se situe pas dans un lieu géographique particulier. C'est comme ça que je le vois, l'art ne se localise pas, il n'est pas lié à la nationalité de l'artiste. Pourvu qu'un espace se crée, un espace qui appelle au dialogue ...'
26. Personal statement by Juan Davila in *D'Un Autre Continent: L'Australie, Le Rêve et le Réel*, p. 102.